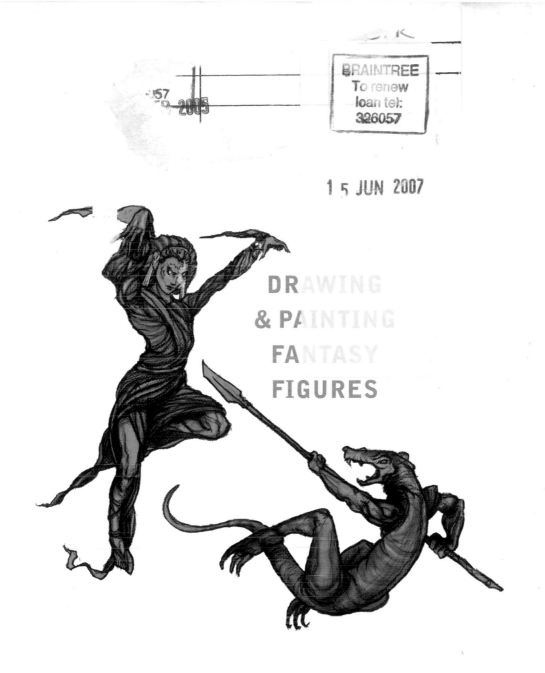

DRAWING
& PAINTING
FANTASY
FIGURES

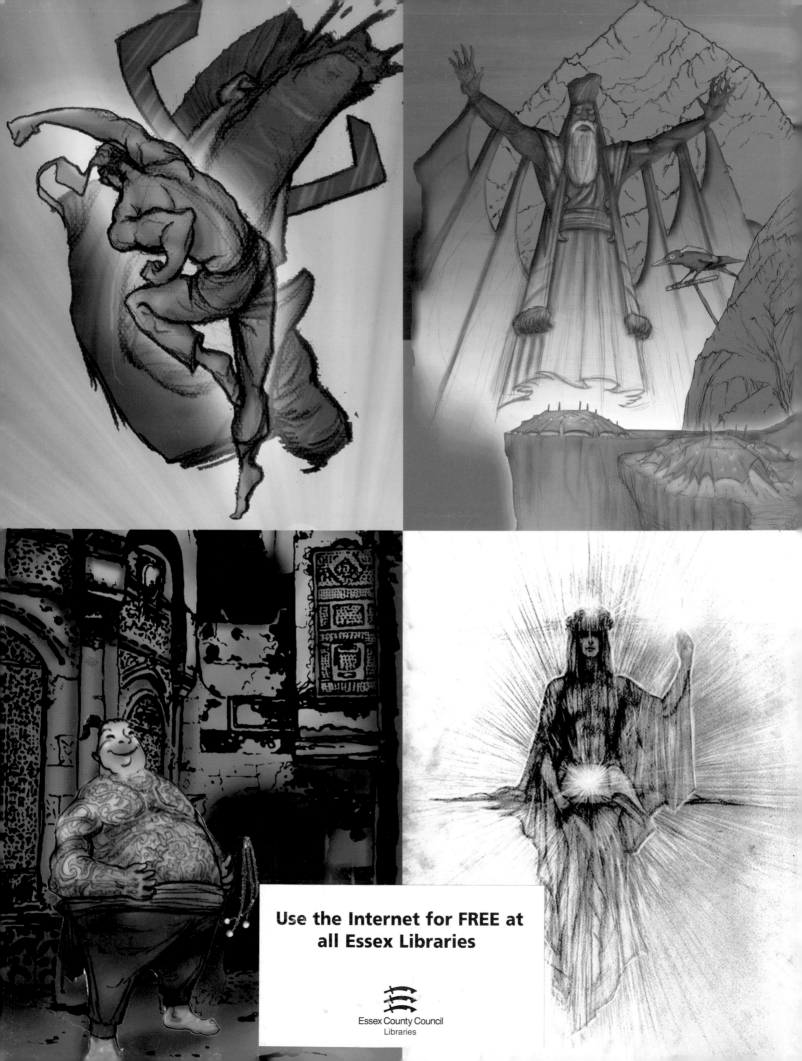

Use the Internet for FREE at all Essex Libraries

Essex County Council
Libraries

Drawing & Painting Fantasy Figures

FROM THE IMAGINATION TO THE PAGE

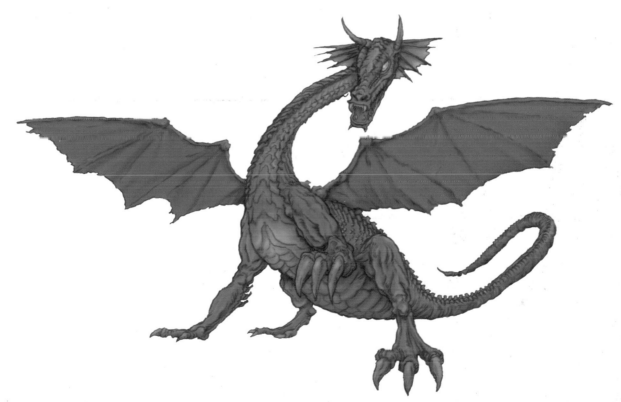

FINLAY COWAN

David & Charles

A DAVID & CHARLES BOOK

First published in 2003 in the UK by
David & Charles
Brunel House
Newton Abbot
Devon

First paperback edition 2004

A catalogue record for this book is available from
the British Library.

ISBN 0 7153 2170 6

Conceived, designed, and produced by
Quarto Publishing plc
The Old Brewery
6 Blundell Street
London N7 9BH

QUAR: DPFF

Manufactured by Pro-Vision Pte Ltd, Singapore
Printed by Star Standard Industries (Pte) Ltd, Singapore

9 8 7 6 5 4 3 2

Visit our website at www.davidandcharles.co.uk

David & Charles books are available from all good
bookshops; alternatively you can contact our
Orderline on (0)1626 334555 or write to us at
FREEPOST EX2 110, David & Charles Direct,
Newton Abbot, TQ12 4ZZ (no stamp required
UK mainland).

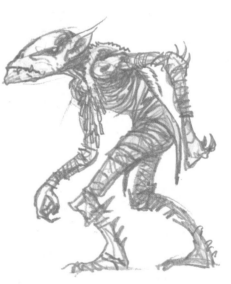

contents

introduction

THE POPULARITY OF FANTASY IS OFTEN EXPLAINED BY THE THEMES OF THE GENRE: GOOD VERSUS EVIL, SACRED QUESTS, THE SURMOUNTING OF LIFE'S OBSTACLES. THESE REMAIN FAITHFUL TO A BODY OF FOLKLORE THAT STRETCHES BACK TO ANTIQUITY.

Most of the fantasy art we see today is influenced by Norse myth, the German *Eddas* and *Niebelungen,* the Celtic sagas and European fairy tales, which also resonate with the influence of ancient Greek, Egyptian and Indian myth. Their themes are echoed in the legends, fables and mythologies of widely differing cultures all over the world, and from the Americas to the Far East, we find that similar stories are told and the same powerful, graphic images endure.

OCEAN OF STORIES

Storytelling, and therefore myth and fantasy, has probably been around since the adoption of language and pictorial representation such as cave drawings. Its role was to exaggerate everyday events in order to pass on to successive generations the rules for survival. For this reason it had an important function in society and storytellers were believed to have considerable powers. The survival of the tribe or society was, to some extent, their responsibility.

The passing on of stories came to have other uses. It made concrete the rules of society and continues to do so right up to the present day. Storytelling also went hand in hand with magic. Druids, magicians and wizards had tremendous powers of memory, and it was their job to retain the histories of their culture and pass them on to apprentices in the days before the printed word.

Stories became a kind of currency that began to travel the world. A good example of this is *The 1001 Nights* or *The Arabian Nights,* a vast collection of stories that began life in India and travelled across continents on the tongues of traders before being collected together by wealthy merchants throughout the second millennium. By the 16th century, professional storytellers were common in the coffee houses of Baghdad, Damascus and Cairo. Their job was to sit on a special seat in the coffee house every night and tell stories that ended with a cliffhanger to ensure that the crowd would come back to the same hostelry night after night. It was the forerunner of the modern soap opera, and these storytellers had the ability to capture an audience and keep them utterly spellbound and begging for more.

Myths – the great classics of antiquity – have informed and inspired generations of artists from ancient times to the present day. This image is based on the story of the minotaur. The line represents the thread used to navigate the labyrinth in which the minotaur was contained.
'Minotaur', Theresa Brandon

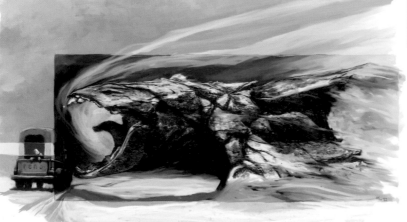

Fantasy artists strive to defy convention, including composition and content, as seen here with the addition of a rectangular panel behind the beast.
'Bulette', Anthony S. Waters

It is impossible to find any single author for these great collections of myths. Each new generation of storytellers has added to the myths and embellished them, and the process continues to this day. Now it's your turn to take up the mantle, blow the dust off the old myths and dive into the ocean of stories.

THE ARTIST'S JOURNEY

Artists, writers, filmmakers and musicians are the storytellers of the modern world. Most artists don't begin their career when they leave school or college; they begin long before that when they first pick up a crayon as a child. It can take years to develop the skills necessary to become an artist and it is an ongoing process. You never stop learning and, as you get better, the process of continuously acquiring new skills becomes very enjoyable.

You can also make a decent living out of it, thanks to the popularity of film and computer games. However, if you want to be in control of your own work, tell your own stories and create your own worlds, you might have to do other things to make the money to support this. There will be times when you have to squeeze your own projects into evenings and weekends, but be assured of one thing: it's exactly the same for everyone who has ever done it. Even if you produce a great graphic novel or film script, you might have to endure years of being rejected and, even worse, completely ignored. Every successful artist has a similar story to tell, so persevere – it's worth it.

GETTING STARTED

The fantasy genre encompasses an enormous range of literary and artistic styles and themes. It can include the space opera of *Star Wars,* the sword and sorcery of Robert E Howard, the horror of Lovecraft and the superheroes of American and Japanese comic books. When you add the world of classical myth and legend to these, it becomes obvious that it would be impossible for any single book to cover everything in the field.

I have therefore tried to focus on the fundamental skills required for creating and drawing fantasy characters and their environments. Wherever possible, I have shown how these skills can be applied to some of the classic archetypes of fantasy art, and have concentrated on revealing useful tips that will hopefully save you hours of trial and error. Throughout the book you will find exercises under the heading 'Over to You', which are designed to help you embark on your journey into your own unique fantasy world.

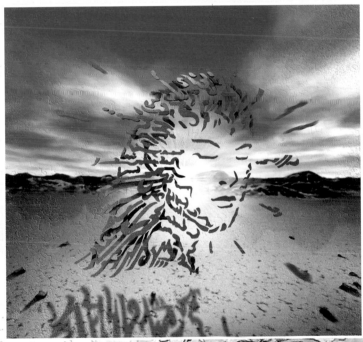

This illustration was produced for an album of North African music by the master musicians of the Jajouka, a group whose lineage dates back 3,000 years. It was intended to suggest the power of the music as it emerged like a dust devil from the wastes of the desert.
'Jajouka', Nick Stone & Finlay Cowan

This development drawing for an animated production of *Watership Down* shows an establishing shot of the legendary Avalon of a group of wandering rabbits. The extreme wide angle and large grasses and flowers in the foreground suggest that the image is a rabbit's-eye view.
'Watership Down', Finlay Cowan

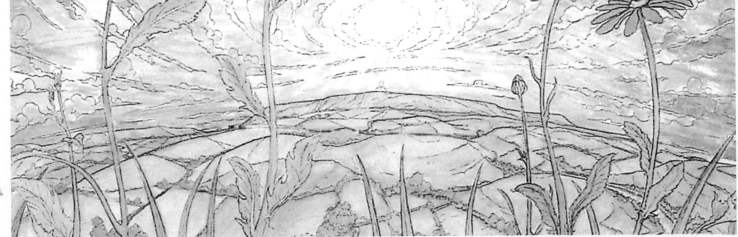

BASICS tools

MOST OF THE WORK IN THIS BOOK CAN BE PRODUCED WITH THE SIMPLEST OF TOOLS. THESE ARE RELATIVELY CHEAP AND EASY TO ACQUIRE AND YOU CAN BUILD UP YOUR TOOLKIT A LITTLE AT A TIME. ALTHOUGH COMPUTER TECHNOLOGY CAN BE USEFUL AT EVERY STAGE OF THE PROCESS, YOU WON'T NEED ALL THE LATEST EQUIPMENT TO BEGIN WITH.

STUDIO EQUIPMENT

It's great to have your own private space to work in, but it's not essential. Many artists prefer to share their working space with others in order to motivate one other and bounce ideas around. Others prefer to work alone because they can find a deeper focus. Whichever you prefer, you will need some of the following basic equipment.

DRAWING BOARD

Manufactured drawing boards tend to be expensive, but you can buy a secondhand one or make your own from a piece of wood with a smooth surface, such as hardboard. It's important to have a drawing board that tilts up for health reasons. If your work is at a good angle, you will have good posture and avoid back strain. The drawing board shown here has a built-in lightbox.

COMPUTER

Some artists use a laptop computer so that they can move it out of the way when not in use. The screen can also be tilted according to posture. Ideally, the computer should be higher than desk height to avoid tilting your head down or forward too much. Your hands and forearms should be supported; you could put padding on your desk for this. The way you set up your computer is dependent on your chair, so you have to organize the two together to get the most comfortable combination.

DESK AND CHAIR

Position your desk in front of a window if possible so that you have good lighting. Choose a good office chair that will support your lower back and encourage you to sit up straight. The height of the chair should allow your forearms to rest on the desk when bent at a right angle, with your feet flat on the floor. The swivel action of the chair can be a real bonus when it comes to turning around to get books off shelves or operate a computer.

LIGHTS

Good lighting is essential in order to avoid eyestrain. Anglepoise lamps are useful because they can be repositioned easily. If you are right handed, place the lamp to the left of your desk so that your drawing hand doesn't cast a shadow on your work, and vice versa.

LIGHTBOX

You can buy a lightbox or make one from an old drawer with a white Perspex sheet on top and a fluorescent strip light inside. Lightboxes are useful for doing different variations of the same drawing. You can draw a rough illustration, place it on the lightbox and then trace it to draw a clean version, an ink version, a watercolour version and so on. They are also useful for collaging images together. Different elements of a composition can be drawn on separate sheets of paper and you can bring them together and modify them using the box. You can use tracing paper on its own to almost the same effect, but it's not quite as good. Some artists use a lightbox built into their drawing board so that they can switch between the two without having to move.

PLANS CHEST

This is a bit of a luxury, but as time goes by you'll find that you need somewhere to store all your artwork; a plans chest is the best choice. Old-fashioned oak plans chest can be expensive, but modern ones can be bought secondhand quite cheaply.

ART EQUIPMENT

The most basic drawing equipment is outlined here. Specific equipment for working with markers, ink, and paint are described on pages 94–95. Computer hardware and software are described in more detail on pages 110–111.

PAPER

Some artists work on A4 paper because it fits most computer scanners, but this is rather small and can affect the quality of the work. As a general rule, it is best to work big. There are many types of paper to choose from. Large sheets of watercolour or cartridge paper are heavily textured and good for tone. Some artists prefer to use smooth, heavy cardboard, which is fairly expensive. Others use light paper, such as layout paper, for visualizing because it's cheap.

PENCILS

Most artists vary between hard and soft pencils, depending on the requirements of the job. As a general rule, thick, soft pencils are great for drawing big and getting lots of expressive tone and detail. Many artists use a technical pencil with soft lead because this gives a consistent line and you don't have to keep stopping to sharpen it. Technical pencils are also great for adding lots of fine detail.

ERASERS

It's good to have one big fat eraser for big fat mistakes and cleaning up, and one fine eraser for doing fine work and adding highlights. A lot of artwork is produced by putting lots of lines into the drawing, then taking some of them out with an eraser, then adding more pencil and going back and forth between the two to build up body and depth. It's good to think of an eraser as a kind of pencil-in-reverse.

DUST BLOWER

A dust blower, available from photography shops, is ideal for blowing eraser debris from your work without smudging it.

BASICS opportunities

THE FANTASY GENRE IS ONE OF THE MOST POPULAR
ENTERTAINMENT MEDIUMS IN THE WORLD. IT IS
IMMENSELY POPULAR IN BOOKS, COMICS AND
FILMS, AND THIS HAS LED TO A GLOBAL INDUSTRY IN
MERCHANDISE, GAMING CULTURE, ROCK MUSIC AND
'FANDOM' (CONVENTIONS, SOCIETIES AND FESTIVALS).

The demand for fantasy illustrators has remained steady for
decades and recent developments in computer-generated (CG)
imagery have served only to increase this demand as Hollywood
uses the genre to develop bigger and better special effects. Fantasy
illustrators have found themselves working in a wide variety of
areas, from producing book covers and comics to all aspects of
design for the big screen.

FILM WORK

Artists working in the film industry are
expected to have computer skills but,
first and foremost, it is essential to have
drawing and visualization or painting
skills. Most artists working in the industry
specialize in certain areas, although there
is a lot of overlap.

STORYBOARD ARTISTS

Storyboard artists work closely with
the film director and art department to
produce a kind of comic strip of the whole film before each scene
is shot. The storyboard shows the camera angles, the movement
of the camera and the composition of each shot in the film.
Storyboards are produced quickly and the style is very loose.

A wide variety of techniques and materials can be used to create fresh and
innovative imagery. This illustration was produced using 3D Studio Max,
Photoshop and Painter software. 'Kim', David Spacil

PRE-PRODUCTION DESIGN

All fantasy, science-fiction and animated feature films benefit from
a long pre-production process in which large teams of diverse artists
are brought together to produce a wide range of drawings, paintings
and sculptures for every aspect of the finished film. Almost all of the
artists who work in this area have drawing and painting skills, and
most have them have computer skills as well.

CG AND ANIMATION

CG and special-effects artists are essential to any
fantasy film production. The computer software that
is used is extremely complex and the technicians
who produce this work are constantly learning new
software. Even though ideas and design skills are not
as essential in this field, most of the artists have
traditional drawing or painting skills.

MODELMAKING

There are numerous companies specializing in the
creation of models, animatronics (advanced puppets),
costumes and armour for feature films and television
series. All of them employ artists, many of whom
eventually specialize in a particular area. For
example, some focus on armour and metalwork,
while others become sculptors of fantasy beasts.

ILLUSTRATION

Fantasy illustrators can find work in a variety of
fields connected with publishing. Although the publishing industry
employs many people worldwide, it is generally not as lucrative as
the film industry. There is also some illustration work available in
the music industry, particularly in the genres of metal and rock.

This Photoshop collage is a good example of how digital technology can be
used to create rich textures and sumptuous colour. A variety of effects have
been applied to create subtle blends and transitions between the elements
to create a seamless whole. 'Collage', Jon Crossland

BOOKS

There is a large global market for fantasy novels, which tend to run in long series. Artists are commissioned to produce the covers and the same artist is often used for the entire series. The work is generally of a different style than that used in the film industry – illustration requires more detail than visualization and the work is generally executed in paint.

COMICS

Fantasy and science-fiction comics and graphic novels for adults and children are a popular genre, and artists may find work as a penciller, inker, colourist, or letterer. Some artists write and illustrate books and comics entirely by themselves.

RPGs

Role-playing games have grown in popularity over the years since the invention of the Tolkien-inspired *Dungeons and Dragons*. There is a constant arrival of new products on the market, and collectors' gaming cards cross over into numerous genres. Artists are commissioned by games manufacturers to develop characters and produce card illustrations.

COMPUTER GAMES

Computer games are big business – the game of a recent Bond movie made more money than the film itself, which makes the film nothing more than an expensive advertisement for the game. Large teams of artists are employed by monolithic corporations to produce ideas and artwork in the same way as in films. There is a need for artists with traditional drawing and painting skills as well as computer skills. Artists often cross over between the film and computer games industries because many of the skills are the same.

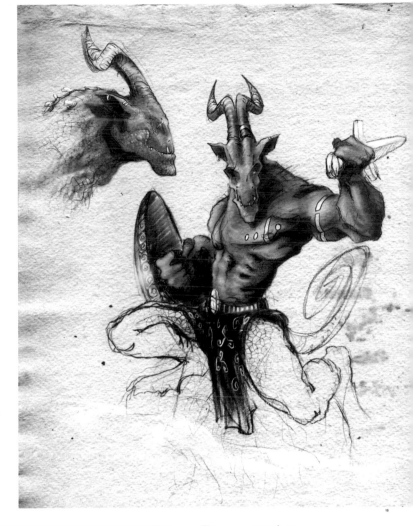

This concept art for a computer game delves into the mythologies of ancient times to create a demonic character for modern-day audiences.
'Vision – Kozel', David Spacil

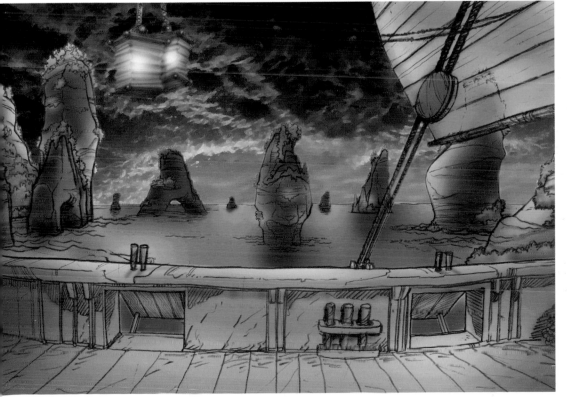

The stark contrast between the deck of the boat and the background scenery is typical of animated films. The image was drawn as a wide angle shot in order to show as much of the background as possible. The curve of the foreground deck and the fanning of the clouds enhance this effect
'South China Sea', Finlay Cowan

BASICS inspiration

THE CHANCES ARE THAT YOU WANT TO LEARN TO DRAW FANTASY ART BECAUSE YOU LOVE THE FANTASY GENRE. HOWEVER, IT IS NOT ALWAYS BEST TO LOOK TO THE GENRE YOU LOVE FOR INSPIRATION. IT'S A GOOD STARTING POINT, BUT FANTASY ART NEEDS TO BE REFRESHED WITH NEW IDEAS IF IT IS TO CONTINUE TO BE INTERESTING.

Educational books are ideal reference tools for the fantasy artist. This secondhand seven-volume set of *Peoples of All Nations* from the 1920s is a great resource for costumes, armour, makeup, jewellery and anything to do with humankind. It also cost about the same as a single 'Making of' book.

ART BOOKS

Fantasy art is heavily influenced by classical art, and many of the most popular fantasy artists learned their techniques from traditional painters. The pre-Raphaelite artists of the 19th century, for example, have been a major influence on fantasy art. Art books are a great source of techniques and imagery but they tend to be expensive unless you can find them secondhand or at the library.

EDUCATIONAL BOOKS

Although art books are great for ideas, they can sometimes be overwhelming in terms of style and technique. For this reason, it's good to build up a collection of general reference books. These are usually educational books for school or college students and it's easy to find large quantities of them secondhand. They don't need to be well printed and the images don't have to be perfect, because what you need is quantity rather than quality – it's more important to have a wide range of images to choose from. Books that seemed rather dull when you were at school can suddenly appear in a new light when you are searching for an image to convert into something else. If you need a reference picture of a snake or lizard to transform into a demon from hell, the whole world of schoolbooks suddenly becomes more appealing.

A good reference library can inspire any number of interesting ideas from the world around us, such as this flower/fairy hybrid. *'Dancing Iris', Myrea Pettit*

'MAKING OF' BOOKS

Other useful sources of inspiration are the 'Making of…' books of films such as *Star Wars* and *The Lord of the Rings*. These books give a good indication of what to aim for if your intention is to work in the film industry. It's important not to fall into the trap of repeating existing ideas, though. Also, these books are usually expensive and it's not easy to find them secondhand.

MUSEUMS

Most major cities have a good natural history museum, which can be an excellent resource for two types of reference. The first is that of animal anatomy. Animal skeletons, and their skulls in particular, are a perfect starting point for drawing fantasy beasts. Similarly, animal skin and camouflage give us ideas for clothing, armour and skin types. The second type of reference is ethnographic or anthropological collections consisting of tribal costumes from around the world, arms and armour, the evolution of humankind, and all kinds of weird and wonderful artefacts. Some of these collections are breathtaking and are often far stranger than fiction. If there isn't a museum near you, there are always the websites.

Museums usually have a large collection of postcards for sale. These are a good way of gathering a collection of interesting material together without having to buy lavish museum guides.

Fill scrapbooks with odd bits of packaging and graphics, no matter how irrelevant they may seem, and add your doodles and scribbles to the books.

SCRAPBOOKS

Collect interesting clippings from newspapers and magazines and keep them in scrapbooks. Don't be too particular about organizing the images into any specific order. That way, you are more likely to spark off interesting ideas as you flip through them. You will often find that as you search for one thing, you'll stumble across something completely different that will set you off in a whole new direction.

MEMENTOES

A memento can be anything from a cast of a skull to a beautiful pinecone or a piece of ornate fabric. Every tiny object tells a story. Why was it made? What does it symbolize? Who owned it? Where has it been on its long journey into my hands? These questions must be right in front of our eyes at all times because we live in the world of stories, where the magic and mystery of fantasy must be part of our everyday lives. I surround myself with various objects because they keep me on course. They are there to remind me that my job is to create and re-create a sense of wonder and imagination in the world.

Mementoes may not always be directly useful as reference but they can help to create an inspiring ambience in which to work.

BASICS developing ideas

WHEN INVENTING A FANTASY CHARACTER, IT HELPS TO HAVE SOME IDEA OF HIS OR HER PERSONALITY. START BY MAKING NOTES, DIVIDED INTO CATEGORIES SUCH AS SKILLS, PERSONALITY, WEAKNESSES AND MOTIVATION.

All characters have 'dramatic need'. This is the thing within their personality that motivates them to do what they do. It could be something that happened to them in their lives, a weakness in their personality or the power of destiny exerting its influence. It is a character's dramatic need that pushes him or her to embark on an adventure. For example, Harry Potter is an orphan who has no memory of his parents, so his dramatic need is to find out who he really is and where he came from. This reveals itself in his personality and ultimately in his expressions — he appears curious and open to new things.

CHARACTER SHEETS

Once you have an idea of the personality of your character, you can start to develop character sheets. These are development drawings that explore a variety of different looks in order to figure out what best suits the personality of the character and to sharpen up and refine the features. This process is essential to animation but useful to all artists.

COMPOSITION

The attitude of a character will affect the overall composition of a drawing or painting when it comes to adding backgrounds. The first thing you must consider is what message you are trying to convey. In other words, what is the atmosphere of the image? Are you trying to create an air of stillness and calm, or should the image have a tone of dark foreboding? It is important to create dynamic impact, so think about the angle of view and the crop of the image as well.

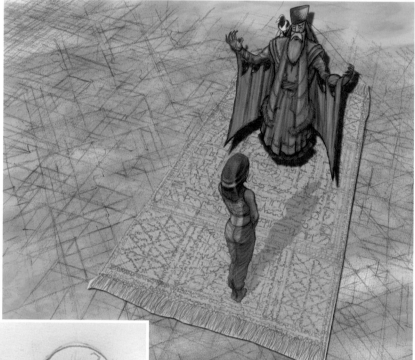

The composition of this development image for an animated feature clearly suggests that the female is a prisoner of the magus, whose position in the image is emphasized by the patterns on the carpet. The background has been deliberately left bare to allow for the focus to remain on the characters.

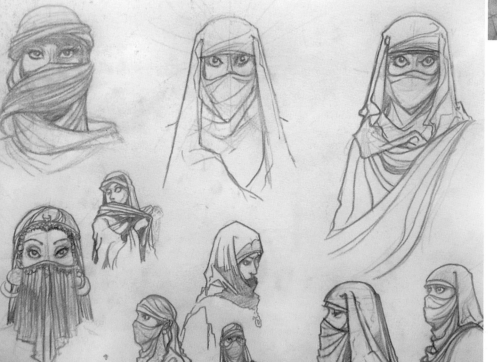

This set of character references was produced for an animated drama of *The 1001 Nights*. Various styles of veil have been experimented with, including Bedouin, Indian and Iranian.

EXPLORING A THEME

Many artists explore the same themes throughout their careers and try several different interpretations of an idea over a period of years. For example, Claude Monet painted the cathedral at Rouen several times, while the surrealist painter René Magritte repeatedly incorporated motifs such as men in bowler hats into his work. Album sleeve designer Storm Thorgerson has similar motifs and themes that recur in his work. I was called upon to develop these different interpretations of a windows theme over a period of years before it finally evolved into a Pink Floyd album release.

1 MADNESS AND INCARCERATION

The windows provided a series of frames in which we could place different objects and events. The framework creates a sense of voyeurism and claustrophobia.

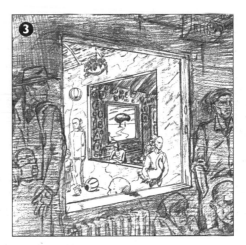

3 PARANOIA AND SUBTERFUGE

This design for Bruce Dickensen's album *Skunkworks* tried to evoke the shadowy world of spies and conspiracy theories. The brain-shaped tree in the far window became part of another idea that made it onto the final sleeve.

2 HOLISTIC NETWORKS

This version of the framework was peopled with symbols and objects that referred to multimedia disciplines and ideas, including the visual arts, literature, music and philosophy.

4 CONFEDERACY OF ECCENTRICS

In this interpretation we used each plane to represent a different individual of the Icelandic group Ragga, referring to the contents of each member's psyche

5 PINK FLOYD POSTER

This compilation of objects from the band's album sleeves was realized for a poster commemorating their 30th anniversary. Although the band liked it, it was passed over in favour of another of Storm's ideas.

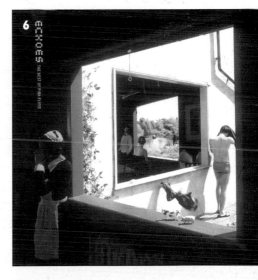

6 PINK FLOYD ALBUM

The windows framework was a good way of showing a collection of objects or ideas in a small space without cluttering a strong composition, which made it ideal for the compilation album *Echoes*. Many sketches later, Storm photographed it with just a little digital retouching.

BASICS storyboarding

**STORYBOARDING IS THE BREAKING DOWN OF A
SEQUENCE IN A STORY INTO A SERIES OF SPECIFIC
SHOTS. IT IS A USEFUL SKILL FOR ANY FANTASY
ARTIST TO ACQUIRE.**

Storyboarding requires you to be fast and to have a great repertoire of reference. It also encourages you to interpret other people's ideas and engenders the ability to tell a story quickly and clearly. Storyboards do not rely heavily on painstaking artistic techniques and style, which can take years to develop. Instead, they require a good grasp of the fundamentals of design, anatomy and visual storytelling. Anybody interested in the genre of fantasy art will require some of these skills, so it is a good idea to start with a quick overview of the fundamentals of storyboarding and how a story is told.

SHOT TERMINOLOGY

The language you use to describe a sequence of events and how it is going to be seen by the viewer can affect the way in which you think about telling a story. So, to begin with, let's look at some of the basic terms used to describe shots in a typical film. Although you may be intending to apply your work to illustration or computer games, thinking in terms of the language of storyboarding may help you to crystallize and focus your ideas before you commit them to paper.

- **ECU (EXTREME CLOSE-UP)** A very close shot that emphasizes a reaction.
- **CU (CLOSE-UP)** The face and head of the subject or object.
- **MCU (MEDIUM CLOSE-UP)** Head and shoulders.
- **MS (MEDIUM SHOT)** Head to waist.
- **MLS (MEDIUM LONG SHOT)** Head to knees.
- **LS (LONG SHOT)** Head to toe.
- **WS (WIDE SHOT)** A scenic shot that shows location.
- **HIGH ANGLE (OR BIRD'S EYE)** Looking down on the actors or objects.
- **LOW ANGLE (OR WORM'S EYE)** Looking up at the actors or objects.

BATTLE SEQUENCE

1 *Fade in to wide shot. Track left to right.* This is also known as an establishing shot. It gives the viewer an overview of where we are and what is going on. We can see a group of soldiers moving towards a besieged city located on a promontory.

❶

❷

❸

2 *Cut to low angle of siege tower.* Thanks to the previous shot, the viewer is aware that we have jumped to the end of the promontory where the battle is taking place. The low angle of the shot emphasizes the action of the soldiers pushing forward against fierce resistance, with the siege machine towering behind them.

3 *Cut to another low angle of siege tower.* The viewer can now see the wall of the besieged city. An arrow denotes that the siege tower is moving up to the city wall, although this arrow is not strictly necessary because the move is already implied. The low angle also establishes the existence of the soldiers at the top of the siege machine, because that is where we are going next.

- **POV (POINT OF VIEW)** A shot that represents the viewpoint of a character.
- **OS (OVER THE SHOULDER)** Looking at something over the shoulder of a character.
- **TRACKING (OR DOLLY)** The 'camera' (ie, the viewer) is moving forward or backward, left or right. Also includes 'track in', 'track out' and so on.
- **ZOOM** The camera/viewer remains static but the frame changes as the subject is magnified.
- **TILT** The camera/viewer tilts up or down.
- **PAN** The camera/viewer turns on its axis to the left or right.
- **CRANE SHOT** The camera/viewer is mounted on a crane and can move in all directions through space.

TRANSITIONS

Here are a few basic terms used to describe how we get from one shot to the next.

- **CUT** An abrupt change from one shot to the next. This is the most common transition.
- **FADE IN** When the image gradually appears from a black or white screen.
- **FADE OUT** When an image gradually fades to black or white.
- **WIPE** When an image appears over another and the first image gradually fades.

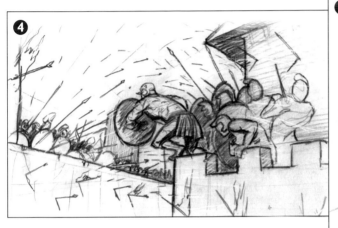

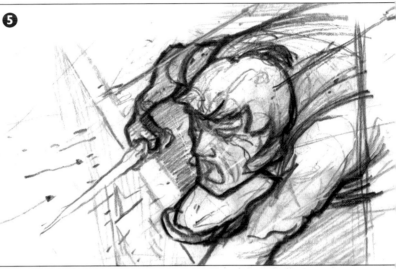

4 *Cut to long shot of top of siege tower with soldiers about to leap across.* Once again, the viewer is in no doubt that we are now at the top of the siege tower facing towards the ramparts of the besieged city because the previous shot established this. The long shot gives us a general impression of what is happening before closing into the action in the next shot.

5 *Cut to high-angle close-up of hero leaping the gap.* This close-up brings our hero into the thick of the action. It establishes that he is the first to leap across the gap. The high angle is intended to show the long drop beneath him and emphasize the excitement of the action.

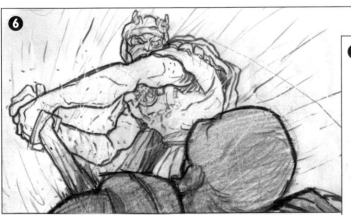

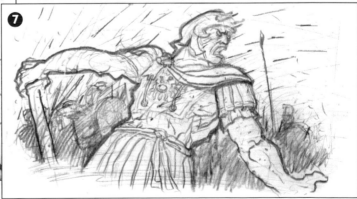

6 *Cut to low-angle, over-the-shoulder medium shot of enemy soldier being killed by hero.* The low angle of this shot emphasizes the drama of the hero in action. The medium shot brings the viewer right into the thick of the action and increases the excitement. By depicting the enemy soldier in an over-the-shoulder shot, the violence is less graphic because the sword can't be seen going through his body.

7 *Cut to medium shot of hero looking around.* The medium shot allows us to see the hero's troops pouring over the wall behind him, clearly motivated by their leader's bravery. A lot of small flecks of mud, blood, smoke and arrows have been added to these drawings to emphasize the chaos of the environment. This gives the sequence an overall impression of speed and movement.

CHAPTER ONE

drawing the characters

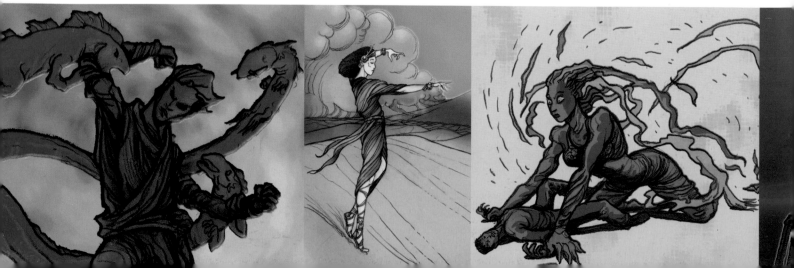

and their worlds

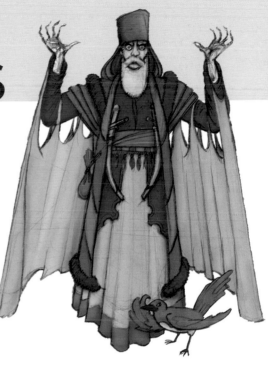

THERE ARE MANY DIFFERENT TYPES OF FANTASY

CHARACTERS, FROM HEROES AND HEROINES TO WIZARDS

AND BEASTS. HERE, YOU WILL LEARN HOW TO DRAW THEIR

FACES AND FIGURES, HOW TO ADORN THEM WITH CLOTHING,

ARMOUR AND OTHER ACCOUTREMENTS, AND HOW TO

ANIMATE THEM CONVINCINGLY. THERE IS ALSO A SECTION

ON DRAWING FANTASY WORLDS FOR YOUR CHARACTERS TO

INHABIT, FROM THE PRINCIPLES OF PERSPECTIVE DRAWING

TO CREATING ARCHITECTURAL DETAIL.

HEROES faces

THE HERO (OR HEROINE) REPRESENTS THE PERSON TO WHOM THE STORY IS BEING TOLD AND PROVIDES A CRUCIAL CONNECTION BETWEEN THE STORY AND AUDIENCE. WITHOUT THE HERO, WE WOULD HAVE NO LINK TO THE STORY AND THERE WOULD BE NOTHING TO MAKE US CARE. THE HERO'S FACE USUALLY PROVIDES A VISUAL KEY TO HIS CHARACTER.

FRONT

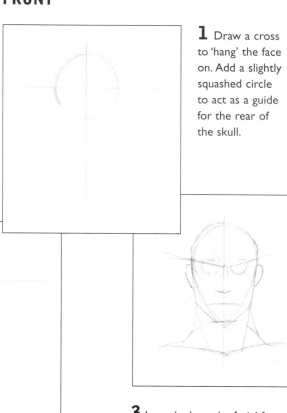

1 Draw a cross to 'hang' the face on. Add a slightly squashed circle to act as a guide for the rear of the skull.

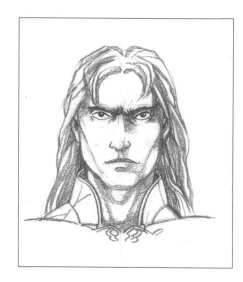

5 Put in the basic shape of the hair. Hair can completely change the look of a character, so start by putting in a few guidelines before adding too much detail. Once you are satisfied, add more shadow to the edge of the face where it meets the hair by thickening the lines.

2 Add some lines for the cheekbones, jaw and neck. Notice that the jaw and cheekbones meet in a point at this stage.

3 Loosely draw the facial features. Always add the line for the mouth first – if you put the nose in first, it tends to be too long and pushes the mouth down too far. Draw the eyes as full circles, which helps to give them depth later on. Draw the eyebrows so that they overlap the eye sockets. Add the neck and collarbones.

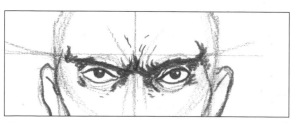

4 Strengthen the lines of the features. Draw the pupils of the eyes, then 'wrap' the shape of the eye openings around the eyeballs. Add shadow to the eye sockets and highlight the pupils. Be prepared to make mistakes and try again. Give some expression to the mouth.

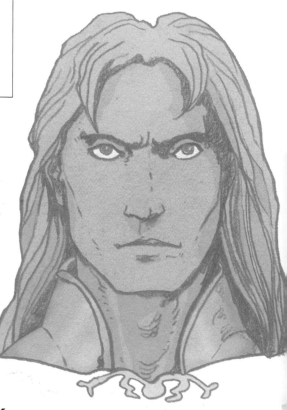

6 If you are pleased with the way the character looks, don't complicate things by adding too much detail at the pencil stage. Instead, you can add depth and detail with colour. This example was coloured using Photoshop software (see pages 112–113).

PROFILE

1 Begin with a squashed oval that tilts slightly forward. Add the front of the face so that it tilts slightly backward. Draw the shape of the jaw so that it intersects the oval where the ear will be. Add the shape of the neck and a line for the chest. In this example, the neck tilts forward and the chest sticks out past the front of the face.

2 Add the shape of an ear and draw a line from the top of the ear to the front of the face. This will be the line of the eyebrow. Add another line from the ear to the point of the jaw for the cheekbone.

3 Add the line of the mouth. Notice how you can add lip detail here. Draw the eye socket and pupil. Add the collarbone and some of the upper body area.

4 Draw the eyebrow. The protruding eyebrow in this example has been exaggerated to add power to the drawing. Draw around the eye and the eyebrow to emphasize the shape and expression. Add the nose and ear detail. You can also see here how the line of the cheekbone has been changed to give it more shape and the line of the jaw has been strengthened.

5 Draw the basic lines of the hair to give an idea of how it flows and hangs. Add a collar and tunic or other type of clothing and ornamentation.

6 Continue to strengthen all the lines to create a strong drawing. Add shadow and detail to the hair and face.

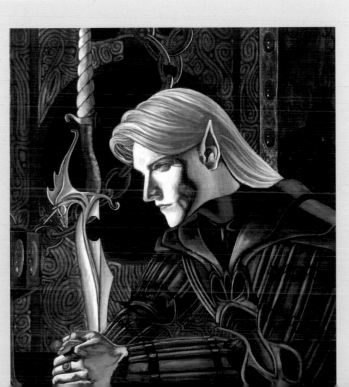

OVER TO YOU

■ *Draw the same character several times to create a series of character studies. This can help you to define your character's personality.*

■ *Choose one of the sketches to colour with ink or paint (see pages 94–109). Trace a copy of it using a lightbox so that you can keep the original pencil sketch. You can then experiment without the fear of ruining the original.*

■ *Scan one of the pencil drawings and colour it on the computer. This method also allows you to try many different versions.*

This hero is clearly an elf in the Tolkien style, with his pointed ears, fine aquiline features, and pale skin and hair. He sits in a contemplative pose, with hands clasped as if in prayer, but he is clearly also a warrior, as revealed by his body armour and sword. 'Royben', Theodor Black

HEROES expressions

YOU NEED TO GIVE YOUR HERO'S FACE AN EXPRESSION IN ORDER TO
EMPHASIZE THE DRAMATIC ACTION OF THE STORY AND GIVE DEPTH
TO THE CHARACTER YOU HAVE CREATED. IT TAKES YEARS TO PERFECT
THE SKILL OF EVOKING EMOTIONS ON THE FACES OF CHARACTERS,
BUT SIMPLE KEY EXPRESSIONS ARE EASY TO LEARN.

DISMAY
Indicate sadness or dismay by tilting the eyebrows upward above the nose.

FROWN
Create a frown by making the eyebrows dip forward into the middle of the face, where they meet above the nose.

RAGE
Rage is the same as a frown but the eyeballs should be wider and the facial muscles more distorted. Adding lines on each side of the nose makes a face look more brutal or angry.

LAUGHTER
The mouth should be open and the teeth should be bright and white. When people laugh, their eyes become narrower.

SHOCK
Make the eye sockets very wide and show the pupils floating in the white of the eyeball. In this example, the eyebrows are dipped down, but this is not necessary.

SUSPICION
Suspicion or deep thought can be depicted by having one eyebrow up and one down. Also, making the mouth go up at one side can give the impression of thought or the sense of an ironic reaction. In this case, the pupils of the eyes are looking to the side as if the hero were thinking to himself.

OVER TO YOU

■ *Think up the character traits of two very different heroes. Write down their skills, strengths, personalities, weaknesses and motivations.*
■ *Think of a scenario in which they would both behave very differently in reaction to the same challenge, and describe how this could work both for and against them.*
■ *Sketch the scene, then ask yourself whether your drawing shows how each character is different.*

Close study of facial anatomy and the use of a mirror are essential for achieving a specific expression – in this case, a mixture of anger and astonishment.
'Warrior Kings, Character 1', Martin McKenna

NATIONALITIES

The fantasy world is inhabited by heroes of all nationalities. These are just a few examples of how you can adapt a face by making a few simple changes.

ARABIC

This hero is young and handsome and has a strong nose. The addition of a short beard and moustache gives him a slightly cavalier appeal. His black hair is cropped short to make him look older and more masculine.

CELTIC

This hero has a much smaller nose than the others, which suggests his Celtic origins. He has thick, red hair and green eyes.

ASIAN

This character has a distinctive nose and cheekbones. He has thick, black hair and pale lips.

AFRICAN

The classic African face can have a wide nose and large, full lips. This hero looks strong and self-possessed. A tattoo has been added on the side of the head.

HEROES bodies

INVENTING FANTASY CHARACTERS ALLOWS ARTISTS TO STRETCH THEIR IMAGINATION AND DREAM UP IMPOSSIBLE FIGURES. HOWEVER, THE BASIC HUMAN SHAPE TENDS TO THE STAY THE SAME, WHICH ALLOWS THE AUDIENCE TO IDENTIFY MORE EASILY WITH THE OUTLANDISH FIGURES OF THE FANTASY WORLD.

PROPORTIONS

THE AVERAGE MAN

Proportion is calculated by measuring the number of heads a figure stands in height. The average human male is roughly 7 heads high but, strangely, tends to look more accurate when drawn as 8 heads.

HEROES

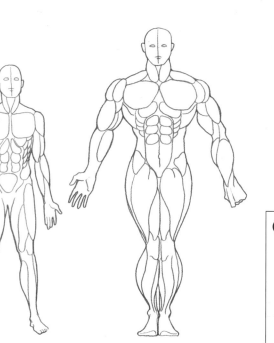

THE AVERAGE BARBARIAN

By comparison, fantasy figures tend to be taller and bigger in every respect. The muscles are exaggerated and stylized.

CONSTRUCTING A BODY

1 One tip for drawing figures is to begin with a few perspective lines (see page 81). This will add impact to the drawing and act as a guide for drawing the lines of your hero's body. Start by drawing a loose stick figure that gives a sense of the overall posture.

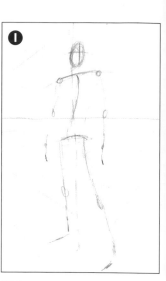

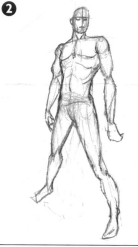

2 Hang your muscle groups onto the stick skeleton. This may involve a lot of erasing and trying different postures. In this case, the right leg was moved farther out to improve the balance of the figure. You don't need to put too much detail into the muscles, but they will affect the way the clothes hang.

OVER TO YOU

■ *Draw a figure, working on the whole drawing at once. Make a series of 'passes', tightening up the drawing with each successive sweep.*

■ *Be prepared to go over many of the lines several times in order to give strength to certain aspects of the figure, particularly the outline.*

■ *Be loose with your drawing. You can clean it up at the end.*

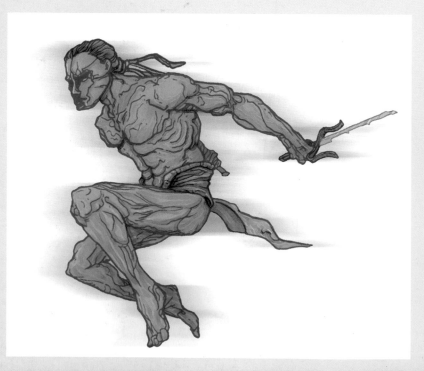

This illustration of a banished samurai warrior features a highly stylized musculature that bends the rules of anatomy. 'Ronin', Finlay Cowan

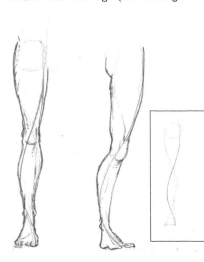

3 By adding clothes you give a definite personality to a character. Notice that this hero's clothes are tight fitting and the lines are drawn outside the original figure lines. Add a few small ridges to represent creases in the clothes wherever the limbs change direction. Continue to work on the whole figure and try not to focus on detail too soon.

4 Allow yourself the freedom to be messy – rough lines often create detail that you can use later on and you can erase anything unwanted at the end. To finish the drawing, trace a 'clean line' version using a lightbox, or simply clean up the original pencil sketch. Here, many of the rough lines have been used to add texture to the clothes and give depth to the expression of the character.

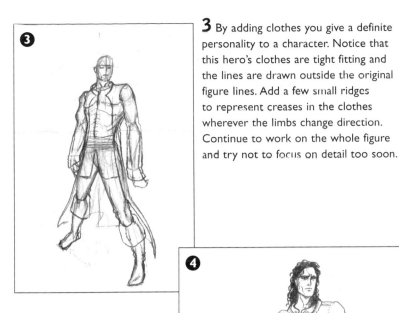

ENERGY FLOW

The posture of the body as a whole, and particularly the limbs, has an energy flow. This is a flowing line that runs through the body, giving the posture harmony and consistency. These drawings show how the muscle groups of the arms and legs seem to form a graceful curve towards the main digit (the forefinger or big toe).

HANDS

Hands and faces are the most expressive parts of the body, so they often require as much attention as the whole figure. Use the same method for drawing hands as you do for the figure. Start with some rough directional lines and build the basic form with simple shapes. Use your own hand as a model and keep a small mirror handy for awkward positions.

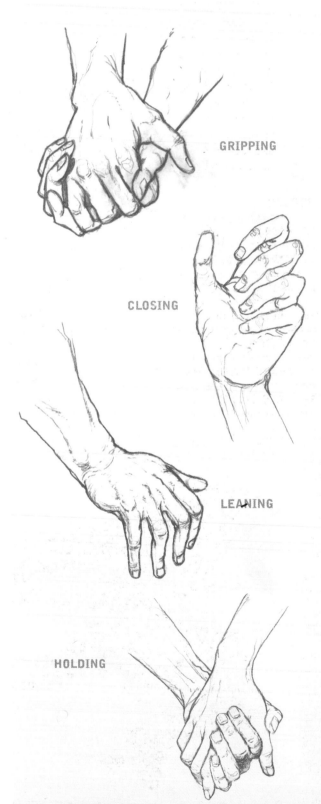

GRIPPING

CLOSING

LEANING

HOLDING

HEROES archetypes

HEROES COME IN ALL SHAPES AND SIZES. JUST THINK OF FRODO BAGGINS IN 'THE LORD OF THE RINGS'. HALF-MAN, HALF-BUNNY MAY NOT BE THE FIRST IMAGE THAT SPRINGS TO MIND WHEN CREATING A HERO, BUT TOLKIEN WAS INSPIRED TO WRITE HIS MASTERPIECE OF FANTASY LITERATURE AROUND SUCH A CHARACTER.

MARTIAL ARTIST

Practitioners of martial arts tend to have lean, well-toned physiques. They keep their hair short or covered. Their belongings might be kept out of the way in a pack fitted tight to their backs. This character has a cheeky smile to suggest that he is something of a 'rough diamond'.

BOY HERO

The boy hero has a slightly larger head in proportion to the body than a full-grown male. Large, clear eyes and smooth skin suggest his moral purity.

DERVISH

Heroes do not need to be muscular to be physically powerful. This character is old but lithe and full of energy. He wears the clothes of a peasant but his expression suggests wisdom and guile – an impression that is not aided by the fact that he is also wearing some very fine tap-dancing shoes.

ICE WANDERER

A character can be easily defined using a simple, striking colour scheme. The ice wanderer is covered head to foot in swathes of clothes and carries most of his belongings among the many layers of cloth. In this case the figure is carrying a weapon shaped like a hockey stick, which gives it a modern reference.

MERCENARY

A mercenary or pirate is older, tougher and less compassionate. He is physically strong but lean due to the hard life he leads.

DESERT WOLF

Heroes or soldiers in hot climates wear turbans and scarves to protect against dust and sun. They also wear light- or dull-coloured clothing.

BODY SHAPES

Standard body shapes, such as short and fat or tall and slim, can be used as the basis for a variety of fantasy heroes.

VIKING

The Viking type is heavier built than the typical hero. He has a massive chest and his posture is solid. This archetype is also suitable for thunder gods, giants, barbarians and heavy rock guitarists. He wears a cloak, tunic, thick wristbands and soft boots. He can have long hair, earrings and tattoos, and will more than likely carry a sword or an axe.

HALFLING

Halflings are short, stocky backwoodsmen who live close to nature. Compare them to the dwarf. Halflings are less muscular and carry less armour. Their clothes are simple and made from rough materials.

DWARF

Dwarfs are stocky creatures with well-developed muscles. This example looks heavy and stands with both feet planted firmly on the ground. Dwarfs are usually shown with beards and heavy body armour. Their clothes might have ornamentation, reflecting their skills as craftsmen.

FAT FRIAR

This figure could also be a wealthy merchant or king. It is built around the huge stomach, and the head and limbs seem to disappear behind the dominant globe shape. The clothing enhances this effect. The knot in the waistband is outsized and the folds of cloth seem to spread out from the figure in all directions. There is a slightly oriental or sumo feel to the figure, which is also suggested by the sandals.

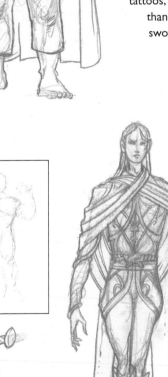

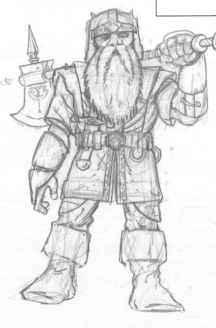

ELF

Compare the body shape to that of the Viking. It is much slimmer, the limbs and hands are delicate, and the whole figure has a lighter feel. Elves have refined features, pointed ears and wear fine clothing. This is a Tolkien-style elf; traditional elves are small and sprite-like.

HEROES action

FANTASY CHARACTERS SEE A LOT OF ACTION IN THEIR BUSY LIVES, AND THEY ARE CONSTANTLY ACTING AND REACTING TO SITUATIONS. THEY RARELY STAND STILL, SO YOU WILL NEED TO BE ABLE TO DRAW A WIDE RANGE OF DYNAMIC, EXCITING POSES.

To start drawing a character in action, you must begin with the 'centre line'. This line gives you the curve or swing of the posture and expresses the body's emphasis in a particular moment of action. Draw a line that goes right through the body, from head to toe, then draw a stick figure around it before adding muscles. The centre line helps to give your drawing an energy flow and rhythm as well as create consistency in the posture of your figures. Remember to consider the personality of your characters when deciding how they should move. Each individual hero will have his own way of swinging a sword or cleaving an orc's skull in two.

CENTRE LINE

1 Although the position of the limbs and sword stray away from the centre line, there is an overall rhythm to the pose in the main shape of the body.

2 The centre line is almost the same but the position of the body is reversed. The sense of dynamic tension is increased by freezing the pose for a split second before the sword is swung.

3 The figure is crouched, preparing to leap, and the centre line suggests the direction he will jump.

TWISTING

1 The body is hardly ever seen in flat perspective. It is always twisting and turning or gesturing in some way, even in subtle movement such as walking. Learning to draw the body in every possible posture is a lifetime's work, but you can practise by reducing the body down to simple geometric shapes. Imagine the waist and torso areas as two separate blocks and try angling them in different ways. Perspective drawing will come in useful here but your lines don't have to be perfectly accurate to work.

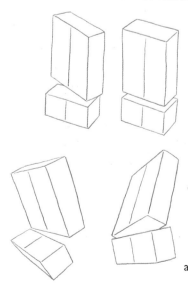

2 Draw the outlines of the bodies around the basic block shapes. This technique can be developed to help with foreshortening and exaggeration.

4 This figure is running slowly. The sense that he is 'loping' is shown in the upper spine, where the centre line curves over.

The composition of this illustration was inspired by a classic 1970s image of Captain America by the artist Jim Steranko. The hero stands in a rigid, symmetrical pose, lifting one of his enemies above his head. Contrast is created in the bodies of his attackers, who writhe and twist wildly around him. *'You Cannot Destroy a Dream!' Finlay Cowan*

EXAGGERATION

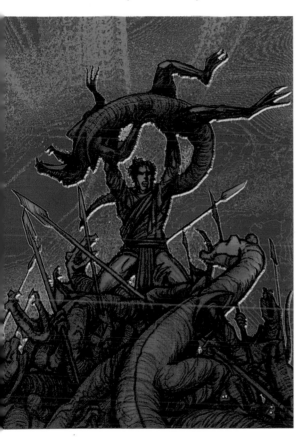

Almost every aspect of the whole genre of fantasy is about exaggeration. Everything we see is bigger, faster, wilder and weirder than anything that came before. This rule filters all the way down to dynamic posture. These two examples show how exaggerating the pose of a figure can give it more impact.

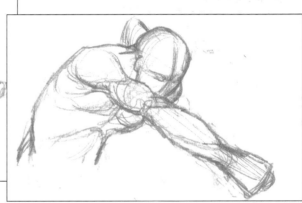

OVER TO YOU

■ *Draw figures from life by breaking them down into simple block shapes. This will lead to a better understanding of the body in perspective and how it occupies space.*

■ *If you have problems drawing block shapes, try using some wooden blocks or a child's doll to help you see the effects of turning and twisting more easily.*

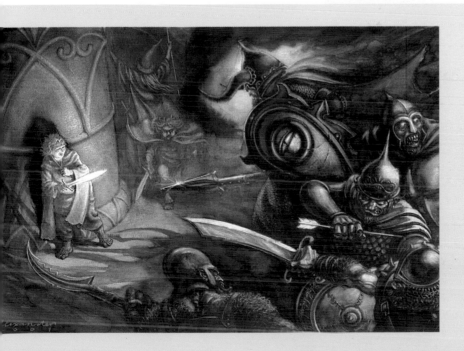

This watercolour painting depicts a typical *Lord of the Rings* scenario. The menace of the hobbit's attackers is emphasized by their size in the foreground, compared with that of their prey, who appears to cower with his back to the pillar. *'For the One', Alexander Petkov*

HEROES foreshortening

FORESHORTENING IS THE TERM GIVEN TO OBJECTS THAT APPEAR TO RECEDE OR GROW SMALLER AS THEY POINT AWAY FROM THE VIEWER. IT IS THE USE OF FORESHORTENING THAT GIVES YOUR FIGURES DEPTH AND EMPHASIZES THEIR ACTION. WITHOUT IT YOUR WORK COULD APPEAR FLAT AND LIFELESS.

1 Draw a simple box with perspective lines to give you a starting point for drawing a figure from a high angle (see page 81).

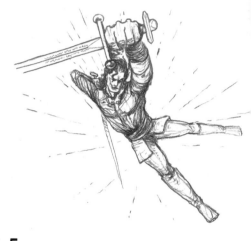

4 This figure is falling through space, probably fighting a flying dragon as he goes. You can see how the block technique has been used to show the twists and turns of the body.

2 Break the body down into simple blocks, with the figure becoming smaller as it recedes from the viewer.

3 Add the curves and muscle detail. Don't worry if you make mistakes – just keep trying. Here, the head is too big and should be reduced slightly.

5 After filling in the detail, draw in some 'whizz lines' to emphasize the perspective.

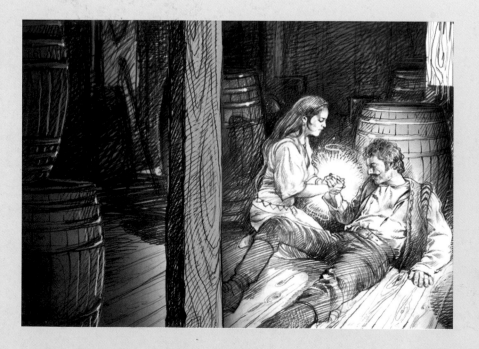

OVER TO YOU

■ *Trace or copy action-filled photographs to help build up your confidence when drawing difficult postures. Be sure to keep your drawing loose and fluid. Put a lot of lines down on the page and find the right one by refinement.*

■ *Don't be too quick to use an eraser if it doesn't look right. Just keep going over the same drawing until it's an abominable mess. It's all good practice.*

■ *Trust your instinct. Sometimes a drawing can look right without the perspective being accurate.*

The recumbent figure has been foreshortened, and you can also see how the upper body is twisted. The barrels in the foreground and background strengthen the depth of field of the environment. *'Journey into the Void', Martin McKenna*

ANGLES

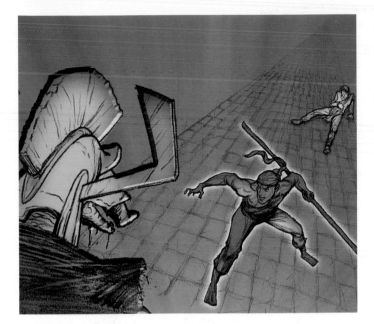

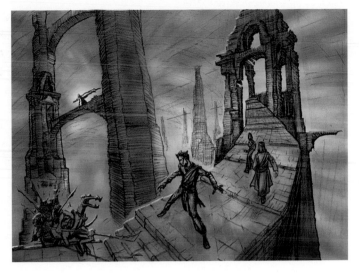

HIGH ANGLE

Note how the posture and composition of the characters affect the impact of the drawing. The high angle of the shot emphasizes the size of the giant lizard. Its proximity to the viewer adds to this effect. By comparison, the extreme perspective makes the hero look small and also emphasizes his action of preparing to spring. The figure who has been knocked down, with his legs splayed out, neatly rounds off the overall rhythm of the composition.

WIDE ANGLE

This wide shot establishes several different characters in action. It shows an event that is about to happen, rather than direct physical action taking place. The hero is central in the frame, with the architecture towering above and dropping away below, which emphasizes the jeopardy he is in. Behind him are his companions, whom he has told to flee while he makes a stand against the approaching hordes of the netherworld. His stance creates a barrier between his friends and foes, and the architecture is arranged to follow the overall centre line of the image. An additional character, the villain, can be seen fleeing across a bridge in the distance, emphasizing the scale of the towers.

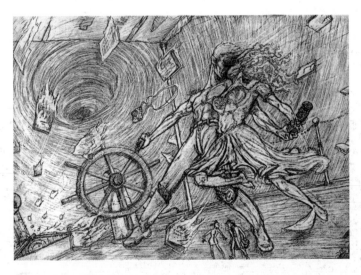

LOW ANGLE

Here, the viewer's angle has been changed to a low shot to emphasize the upward thrust of the hero as he knocks out his foe. The centre line of the hero and the centre line of the foe curve in opposite directions to create tension in the overall composition.

STRAIGHT ON

The centre lines of the hero and heroine sweep together from the deck of the boat, creating an obvious connection between them. Their combined position shows them leaning backward to balance against the forward thrust of the boat. The lines of the boat all thrust forward, which is emphasized by the clutter that is flying past the figures. Additional emphasis is created by the positioning of the whirlpool, which has been tilted at an extreme angle and adds to the sense of the figures plunging helplessly towards it.

aerial battle

THIS AERIAL BATTLE SEQUENCE WAS DESIGNED FOR AN ANIMATED FEATURE FILM ENTITLED 'DREAM THIEVES'. THE ARTWORK WAS INTENDED TO SHOWCASE THE GRAND FINALE OF THE STORY, IN WHICH A GROUP OF HEROES CONFRONT AN ARMY OF REPTILE WARRIORS AND THE HERO IS REUNITED WITH HIS LONG-LOST MOTHER.

The artwork shows examples of a variety of different action poses. The fact that all the characters are in mid-air gave me the challenge of drawing the heroes and villains from many different viewpoints with extreme perspectives. I drew each character on a separate piece of paper and scanned them into a computer. I then arranged them into one piece of art using Photoshop (see pages 112–113).

MOTHER
The mother figure is reaching out to the hero. Her pose is elegant, flowing and non-aggressive. She seems to be assuming an almost yogic position and is being held aloft by a magical flying book.

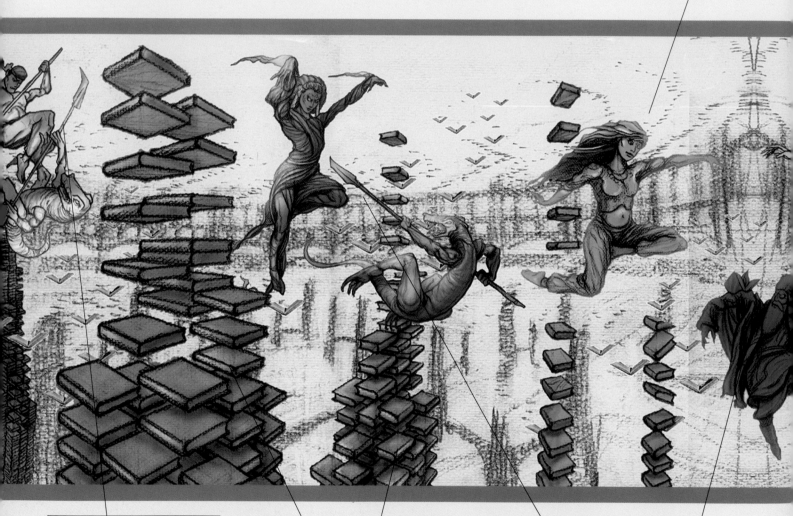

WARRIOR
The warrior is in combat with a reptile soldier. The low angle shows him towering over his foe, in a position of victory, with his head bent forward to suggest a state of intense focus. The reptile is bending backward as it falls away in defeat.

BOOK TOWERS
The floating towers of books are drawn so that they cross the horizon line – that is, the viewer is looking down at the bottom books and up at the top books. This meant that the drawing had to be located carefully in the final artwork, and the position of the other characters had to relate to the book towers for the perspective of the whole artwork to make sense.

HEROINE
The heroine is bearing down on a reptile. She appears majestic and elegant, and her pose is harmonious and strong. The lines of her clothes are fluid and graceful and match the lines of her body and its movement. The reptile appears to be cowering and desperate by comparison.

VILLAIN
The villain, an evil magician, has been disarmed by several flying books. His demeanour is one of helplessness and an inability to act.

HERO

The hero is reaching out to his mother. His pose is majestic and serene, as befits a victor. His spread arms and symmetrical pose suggest he is confident and in control of his movement.

WIZENED OLD HERO

A wizened old hero confronts two reptiles. His symmetrical pose is balanced by the position of the two reptiles on either side of him. Their demeanour suggests an unwillingness to attack, whereas his pose appears domineering and confident.

MALE SKY SURFER

The sky-surfing hero is drawn with extreme foreshortening because he is seen almost directly from below. In contrast, the reptile bends over in the opposite direction, creating a dynamic tension in the frozen moment.

FEMALE SKY SURFER

The sky-surfing heroine is seen from above and is subject to extreme perspective. The reptile is completely at odds with her, upside down and extremely twisted. The reptile's lance forms a strong compositional line between the two characters and is the only element not subject to distortion. The action is shown a split second after impact, which emphasizes the feeling of two bodies in motion, clashing and then moving away from each other.

BACKGROUND

The background is just a rough sketch so that it doesn't interfere with the complex arrangement of the characters. It has been repeated to make it wide enough. The proper design of the background was dealt with separately.

VILLAIN'S SIDEKICK

The villain's sidekick, a thieving magpie, is confronted by another flying book. The magpie's pose is one of alarm.

FRIENDLY TOUCAN

A friendly toucan, seen from above, is swooping up to confront the evil magpie.

FAT HERO

The fat hero appears to be rushing headlong towards the blade and the reptile seems solid and fixed in his position. The moment is lightened by the fat man's demeanour, which adds a comedic touch. Note the contrast between the body shapes of the two figures. The fat hero is very round and stubby, while the reptile is a long, elegant S shape.

HEROINES faces

DRAWING FACES IS RELATIVELY EASY BECAUSE THEY ARE ALWAYS MADE UP OF THE SAME BASIC ELEMENTS ... APART FROM THE OCCASIONAL EXTRA EYE OR PAIR OF TUSKS. THE PERSONALITY AND CHARACTER OF THE HEROINE IS VERY MUCH IN HER HAIR AND ADORNMENTS, WHILE DIFFERENT EXPRESSIONS CAN BE ADDED IN THE SAME WAY AS YOU WOULD FOR HEROES.

FRONT

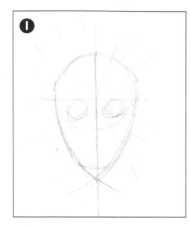

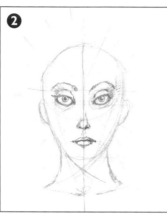

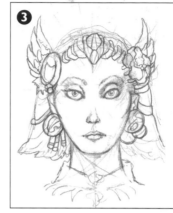

1 Draw a cross shape with a slightly squashed circle on top of it to form the back of the cranium. 'Hang' the face onto this using the shape of a mask to guide you. Notice how the lines of the jaw meet at a point and the chin is formed by drawing a line across it.

2 Add the mouth, nose and eyes. The trick with the eyes is to draw the whole eyeball and then position the pupils. Sit back from your drawing to check that the pupils match each other. You can then 'wrap' the eyelids around the shape of the eyeball. This makes them more realistic.

3 Add some lines radiating out from the bridge of the nose. These will help you give depth to the features and define the adornments. Keep going back over the eyes, adding eyelashes and gradually strengthening the eyelids. They tend to look better the more you go over them. Start to take out some of the construction lines with an eraser but don't clean it up too much – those messy lines come in useful.

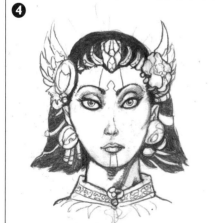

4 Give the adornments as much depth as possible by drawing the basic shapes first, then adding a little bit of detail in a series of successive sweeps over the artwork. Refine the adornments by erasing them bit by bit and then redrawing them. Keep strengthening the outer lines.

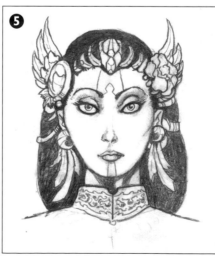

THREE-QUARTER

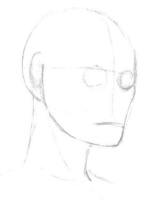

1 The three-quarter view is probably the most common angle at which you will draw a face. Construct the basic shape by hanging a mask on a sphere. Draw the centre line, which will dictate where the face is pointing. Always add the line of the mouth before the nose.

5 Add shadow underneath all the jewellery and the jawline. Continue to clean up with an eraser, going right up to the lines. Still not happy? Try a different hairstyle. I also decided to carry through the feather motif from the headdress into the earrings and to alter the collar.

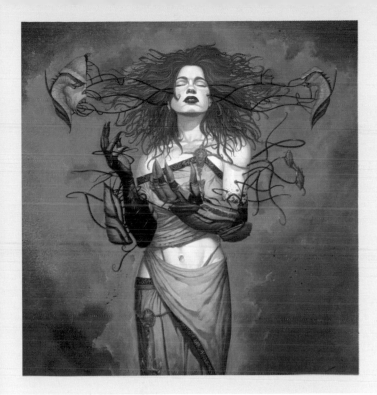

OVER TO YOU

■ Think about the personality of the heroine you wish to draw and do a couple of test drawings. Make them as good as you can, then say to yourself 'now for the real one' and start again.

■ Don't be discouraged by failures. The frontal view shown here was the third attempt I made. This is all part of the process of getting to know your character so that you will be able to draw them confidently in a variety of situations.

This heroine exudes elegance, but the tendrils and props attached to her suggest a darker side to her personality. 'Unmask', RK Post

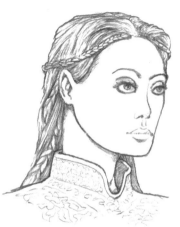

2 Add the eyes as described previously. Noses, mouths and ears are a matter of personal taste and practice.

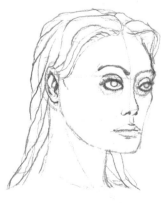

3 Add hair by drawing it in blocks. This will help to give the hair body and form when you fill in the detail. Keep refining the eyes and eyebrows as you go along.

4 Darken the lines of the blocks of hair when you add in the rest of the strands. I've also added braids for variation. Use a fine eraser to create highlights on the hair. Repeat this process to develop tone and depth. This face has been significantly cleaned up, in keeping with the personality of the heroine, and a shadow has been added along the hairline. Finally, an outline was drawn around the whole head to give it strength. Some detail on the clothing gives the character presence.

NATIONALITIES

EUROPEAN
The nose is long and straight and the jaw is large and angular.

ASIAN
This face has a strong nose, pronounced brow and a turned-up lip close to the nose.

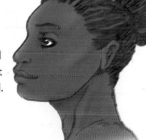

AFRICAN
This face has full lips, a flat nose and a sweeping forehead.

JAPANESE
The wide face has large eyelids, both above and below the eye. The nose is long and straight.

HEROINES bodies

THE MOST NOTABLE DIFFERENCE FROM THE MALE BODY, APART FROM THE OBVIOUS, IS THAT THE FEMALE HAS A NARROWER WAIST AND WIDER HIPS, AND THE STOMACH TENDS TO APPEAR LONGER BECAUSE OF THIS. THE SAME MUSCLE GROUPS APPLY, BUT DRAWING THE FEMALE REQUIRES MORE CURVES AND A SLIGHTLY MORE FLUID APPROACH.

PROPORTIONS

THE AVERAGE WOMAN

The average human adult female is drawn approximately 7–8 heads in height, just like the human adult male.

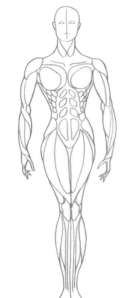

THE AVERAGE WARRIOR PRINCESS

Female fantasy figures are subject to the same exaggeration as males. They are drawn taller, so the head is proportionally smaller in comparison to the height of the body. The shape of her figure is also heavily stylized. Japanese Manga art females, for example, have absurdly tiny waists and enormous eyes.

STRUCTURE

1 The torso area can be constructed by drawing an upside-down triangle that has the bottom of the spine as its base. Note that the hip line starts right down at the knee and flows in a single curve (give or take the occasional undulation) right up to the bottom of the ribcage.

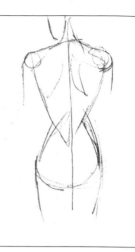

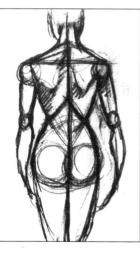

2 A good technique for shaping the hips is to add a pair of slightly overlapping circles just below the inverted triangle. These circles will provide the shape of the buttocks and a 'ball socket' around which you can build the shapes of the legs.

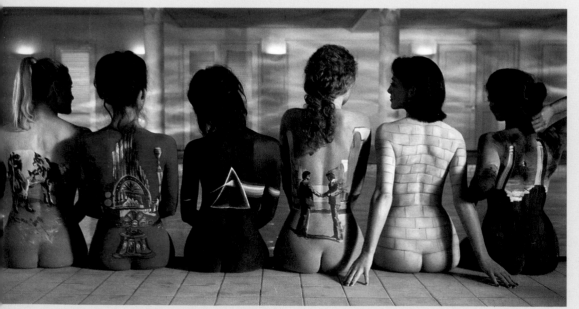

OVER TO YOU

■ *Study the Pink Floyd image and try drawing characters in the same pose but with different attitudes.*
■ *See how the spine and back muscles change, depending on the subtleties of posture, and assess how this could affect personality.*

In this image, created for the rock group Pink Floyd, you can see how six different figures have the same basic posture but with subtle differences in the shapes of the spines and shoulders. *'Back Catalogue', Storm Thorgerson, Finlay Cowan & Tony May*

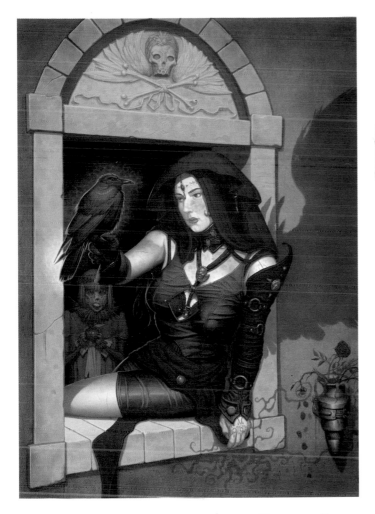

The posture of this figure sits well in her environment. The tension of her left arm and twisting of her body show sound anatomical study. Note the shadow of the wing behind her, which raises questions about the nature of her character. 'Magdiel', RK Post

TWISTING AND FORESHORTENING

WIRE FRAME

The foreshortening of this figure has been achieved using the wire frame technique. This is done by constructing the figure out of hoops that run horizontally and vertically around the body.

BLOCKS

Another method of calculating twist and foreshortening is to break down the figure into simple blocks. Notice the extreme perspective of the thighs and the arching of the upper torso in relation to the hip area. This method can be difficult to use.

SPIRALLING LINES

Take a more fluid approach and begin with a centre line and stick figure. Develop the shape of the figure by drawing spiralling lines around the basic stick shape, much like the wire frame technique. This quickly gives the impression of being able to see right through to the back of the body and helps to strengthen the shape.

BALANCE

1 Draw the centre line and sketch in a stick figure. Build up the form of your figure, starting with the hip area. This will allow you to emphasize the way the figure is balancing. In this drawing, the upper torso and legs arch away from the hip area, creating a sense of poise.

2 Here, the hips are arranged one higher than the other. This affects the whole posture, causing the upper torso to compensate and creating a sense of the weight being placed on one leg.

3 In this case the balance of the figure is perfectly symmetrical. It was drawn beginning with the hip area and then outward to the limbs.

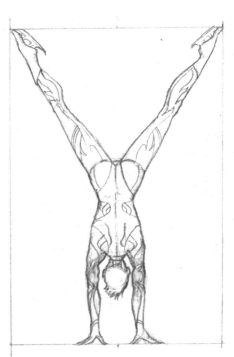

HEROINES costume and hair

CHARACTERS ARE VERY MUCH DEFINED THROUGH THEIR PHYSICAL APPEARANCE AND COSTUME. THE EXAMPLE OF A MUSE BELOW SHOWS HOW A CHARACTER CAN CHANGE BY MAKING EVEN SMALL ALTERATIONS TO COSTUME AND HAIR DURING THE DEVELOPMENT PROCESS.

MUSE

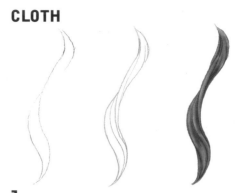

1 A muse is generally defined as a female who brings inspiration to artists, poets and adventurers. Inspired by the work of artists such as Frederic Leighton and Gustav Klimt, this sketch shows the muse as a young lady in a kind of pre-Raphaelite or art nouveau style.

2 With her free-flowing hair and garland of flowers and leaves, she is clearly in the May Queen mould, a kind of spirit of the woods.

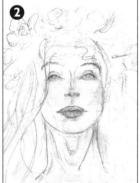

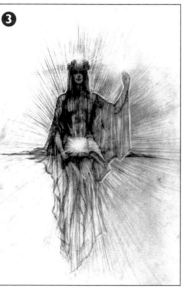

3 In this second approach, the figure has become more like an angel from the Christian tradition and the overall image is more gothic as a result. The headdress is now more severe and the dress has long, dramatic sleeves that emphasize her commanding pose.

4 The final approach has returned to the original idea of a younger muse figure. The sleeves and collar of her dress are now very simple, reflecting her air of quiet contemplation. Her hair flows languidly down her back.

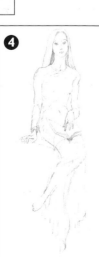

5 Notice the refinements from the rough sketch to the final. The right hand has been adjusted and the hair has been given more volume, which noticeably changes the impact of the figure. The most obvious change is that of the dress, going from a full dress with a round neck to a kind of diaphanous wrap.

CLOTH

1 Draw a couple of intertwining lines, then add a few more lines to the basic shape to give it body. Finally, add shadows behind some of the lines to give the impression of folds and creases.

2 Experiment with different kinds of lines to get different cloth and hair effects. Here, a few overlapping jagged lines form the basic structure for a different kind of look.

HAIR

Braids are an essential element in fantasy hair design. No self-respecting princess would leave the castle without them. The most basic kind can be drawn using two parallel lines that cross over. Add a series of diagonals, then go back over them, turning them into little bunches with shadow at the centre.

HAIRSTYLES

These examples of hairstyles demonstrate how dramatically you can change the personality of your heroine simply by changing her hairstyle – or lack of it.

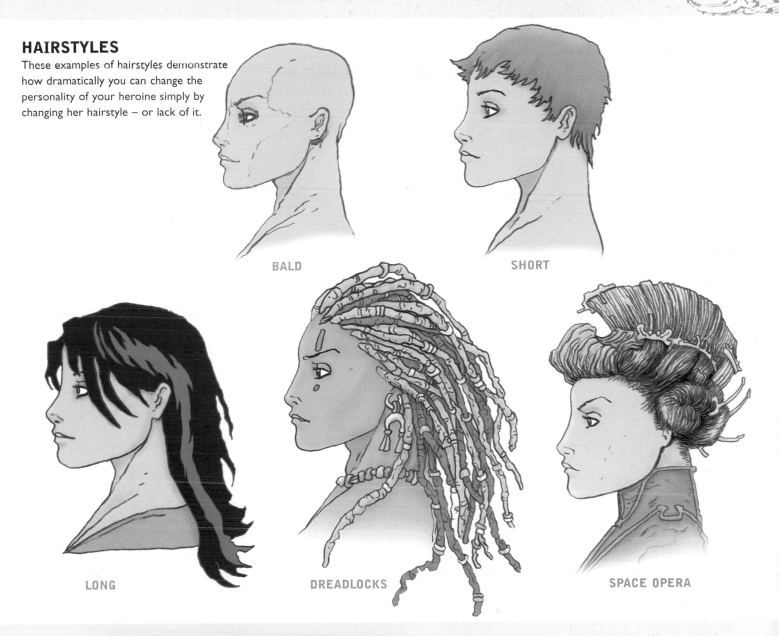

BALD

SHORT

LONG

DREADLOCKS

SPACE OPERA

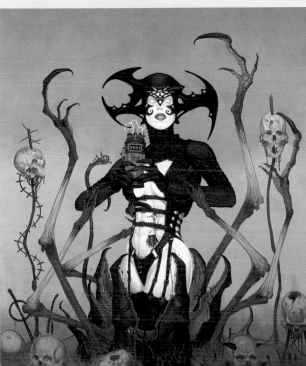

OVER TO YOU

■ It is easier to design characters when you really know who they are. Choose a female character from myth and find out as much as you can about her. You could try Morgan le Fay of Arthurian legend, for example.

■ Draw a character sheet, showing your heroine in different clothing and/or hairstyles. Compare the different looks you can create by making small alterations, and assess which best suits your character.

This fetishistic figure is clearly at one with her environment, and her costume follows suit. The asymmetry of her head garb fires the imagination by presenting us with the unexpected. 'Indigestion', RK Post

HEROINES adornment

DESIGNING HIGHLY DETAILED ORNAMENTS AND
JEWELLERY MAY APPEAR DIFFICULT AT FIRST, BUT ALL
YOU NEED TO DO IS BUILD IT UP GRADUALLY FROM BASIC
ELEMENTS AND FILL IN THE FINE DETAIL LAST.

JEWELLERY

❶

1 Draw the basic shapes with a
clear centre line. The perspective
lines will remain on the drawing
right up to the last moment –
they act as a guide for detail.

❷

2 Draw in lines for the eyelids,
mouth, and nose to give them
form (you will erase these
lines later). Keep reworking
the features with a pencil and
eraser. I decided to remove
the robe and make the drawing
more symmetrical. If something's
not working, don't be afraid
to change it or come back
to it later.

❸

3 Add more detail to the
jewellery. It should just be
basic, flat outlines at this
stage. I used the flowing lines
of the shoulders to invent
some traceries of jewellery
across the chest area. I still
haven't decided on a lot of the
detail. I'm just exploring with
the pencil and seeing what
shapes present themselves.

❹

4 Add the hairline and strengthen
the shapes around the face. Begin
to add more jewellery in the gaps
between the main items. The features
still have a lot of lines around them,
which adds tone.

❺

5 Start strengthening lines that
work well for you. This involves
going over some lines and erasing
others. Go around the outlines of
each item of jewellery to strengthen
it. Add shadow and detail to
individual jewels. Continue
strengthening lines and erasing them
again – backward and forward as you
build up the strength of the picture.

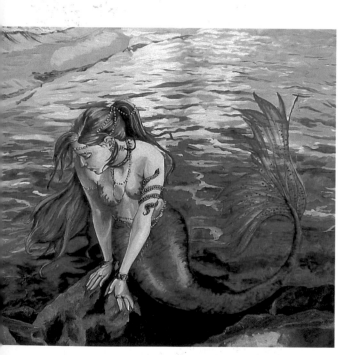

The blue colour palette of this painting is enhanced by its
contrast with the body and head jewellery, which have been
executed in a different colour. 'Blue Mermaid', Tania Henderson

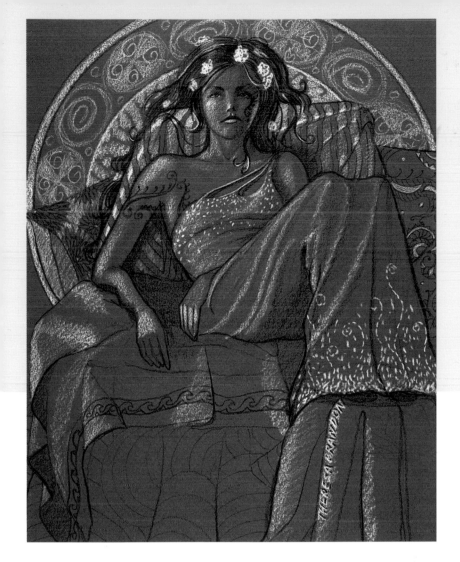

OVER TO YOU

■ Look at photographs of historical and tribal jewellery and adornments from around the world for inspiration. Like many things in fantasy art, it's a matter of taking what exists in our world and exaggerating it.

■ Copy the images you like and convert them into three very different fantasy characters. You'll see how, in some cases, the adornments define the character.

This pre-Raphaelite-inspired acrylic painting makes sensitive use of subtle details on the clothes, which are mimicked in the tattoos on the face and arm. Flowers in the hair provide additional adornment. 'Nouveau', Theresa Brandon

OTHER ADORNMENTS

TATTOOS
This heroine has the body ornamentation of facial tattoos in addition to her elaborate jewellery. Her elegant hairstyle emphasizes her regal posture.

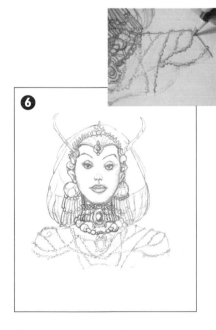

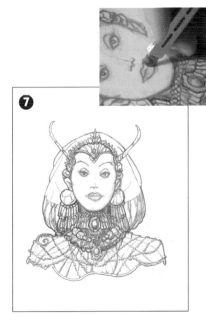

6 Add drop shadows to the jewellery. This is a thicker line on the underside of each component. Clean up the last few perspective lines.

7 Add an extra thick line around the outside and other elements that you consider important. This makes the image stronger. Finally, use a fine eraser to put highlights on the lips, nose and jewellery. These touches can really add life to a drawing.

FLOWERS
A character can be given a strong, memorable identity by the addition of a single ornament, such as this oriental heroine with a large yellow lotus flower in her hair.

HEROINES archetypes

EVERY CULTURE ON EARTH HAS A DIVERSE PANTHEON OF MYTHICAL FIGURES FROM WHICH TO DRAW INSPIRATION. FROM EUROPEAN FAIRIES TO INDIAN DESTROYER GODDESSES SUCH AS KALI, THE TRADITIONS OF MYTH HAVE SUPPLIED US WITH A STUNNING VARIETY OF FEMALE ROLES THAT ARE WIDELY USED IN THE FANTASY GENRE.

EARTH GODDESS

1 Ida, a singer from Sweden, provided the model and personality for this character. Her strong features and long limbs suggested someone who would have tremendous elemental power, such as a priestess or Earth goddess, as opposed to something lighter, like a fairy or wood nymph. This rough sketch was made by tracing the basic features from a photograph Ida provided of herself in a meditative pose.

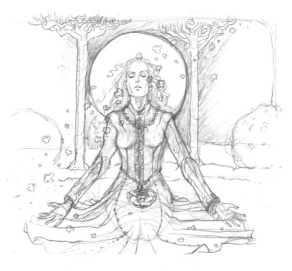

2 Here, the position of the legs has changed from an Eastern yoga position to a kneeling posture. Thinking about the character led to the idea of framing her with two trees and a large moon behind. This gives the drawing an art nouveau feel.

3 The final drawing was made by tracing the figure on a lightbox. Details were then added to the dress. The obvious choice was to create a simple, elegant, princess kind of dress. The background was dealt with separately using Painter software (see pages 114–115).

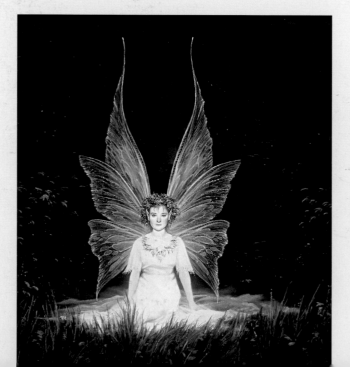

OVER TO YOU

■ *Research ancient myths in books, on the Internet and in museums. In European myth you will find fairies, witches and banshees. Egyptian, Roman and Greek myths are filled with sirens, priestesses, goddesses and fates. In Native American myth there are Mother Earth and fertility spirits. Use these references to develop a new character of your own.*

■ *Look at people you know and assess how their appearance and personalities relate to a mythological character. Choose one and use a photograph of her as the basis for designing your fantasy figure.*

This fairy possesses the typical attributes of grace and fine lines, but she also has a strong jawline and questing eyes that belie an inner strength of character. 'Breath of the Bright Fey', Anne Sudworth

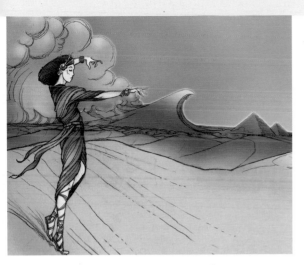

This princess has the power to control the sands of the desert, creating a sandstorm at will. Her clothes reflect her power and have the colour and shape of rippling sand dunes. *'Princess Zobabah', Finlay Cowan*

AMAZONIAN QUEEN

A queen always has a regal bearing, suggested here by the symmetry of her pose. Her appearance is dominated by her rich clothing. As a rule, Amazonians tend to be large.

ARABIAN PRINCESS

This heroine is clearly strong and confident, and her look belies a certain wisdom. She is a queen of storytelling, like Scheherazade in *The Arabian Nights*.

FAIRY

A fairy should have a lithe figure. Everything about her is light and airy, including her clothes. Her body shape is petite and elegant, like a ballet dancer.

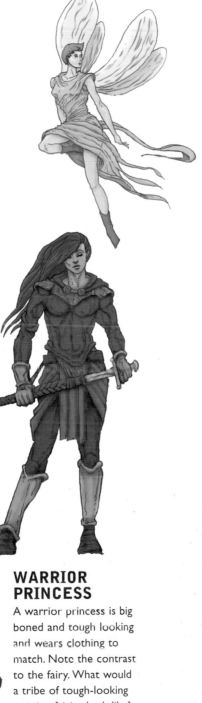

WARRIOR PRINCESS

A warrior princess is big boned and tough looking and wears clothing to match. Note the contrast to the fairy. What would a tribe of tough-looking warrior fairies look like?

FEMMES FATALES

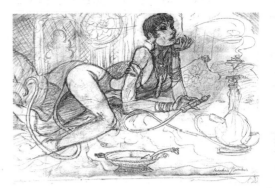

SUCCUBUS

This demonic seductress, who descends upon men in their sleep to have sexual intercourse with them, is seen here relaxing in her lair. She is lying on a bed in a posture that emphasizes her well-rounded hips and draws the eye to the sting in her tail, making her lustful intentions clear.

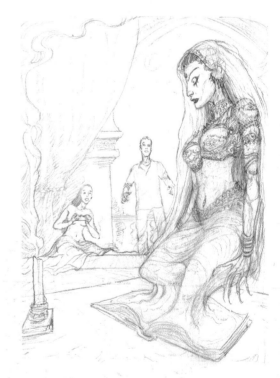

GENIE

A female genie is seen here rising from an ancient manuscript. These figures from Eastern myth were believed to be ghostly spirits who could seduce human males or females. Consequently, she is sexy looking, but her evil intent is suggested by her downward sloping eyes and long, curving fingernails.

HEROINES dynamic posture

NEXT TO LIFE DRAWING, LOOKING AT SCULPTURES IS THE BEST WAY TO LEARN TO DRAW FANTASY FIGURES. SCULPTURES DON'T FIDGET, THEY HAVE GREAT PHYSIQUES, THEY OFTEN DEPICT SCENES FROM MYTH ... AND THEY'RE FREQUENTLY NAKED, UNLIKE REAL PEOPLE.

Sculpture covers all the fundamental technical aspects of fantasy drawing.

The figures twist and writhe; their towering size encourages the artist to learn foreshortening; and they are always well lit, accentuating shadow and muscle form.

DANCER

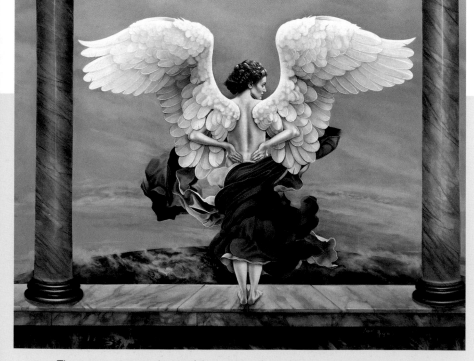

1 These drawings of dancers were heavily inspired by temple carvings in India and are good examples of extreme twisting of the figure and expressive gestures of the hands and head, which emphasize character and movement. Draw the basic stick figure first.

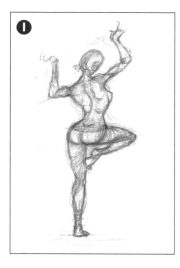

2 Clothes have been added here, and you can see how the shape of the figure in the original sketch has dictated how the clothes hang. A background scan of mottled paper gives the drawing an ancient feel.

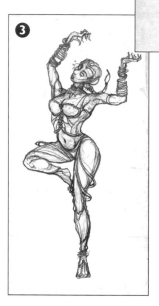

3 The pose is roughly the same, but this time the figure has been drawn from the front. When beginning with a stick figure, you will often find that you can draw the figure from either side.

The strong, symmetrical pose of the angel is enhanced by the symmetrical pillars. The placing of the hands on the lower back adds strength and stability to the image, which contrasts with the fluidity of the billowing folds of cloth and the softness of the wings.
'Guardian at the Gate', Carol Heyer

OVER TO YOU

■ *Sculptures give us the opportunity to draw the same pose from different angles. Choose a sculpture and try drawing it from three different positions.*

■ *Now concentrate on drawing some of the details of the sculpture from different angles. Sculptures are the perfect resource for all those tricky little anatomical details that are the hardest to learn, such as how to make toes look interesting. What more could you wish for?*

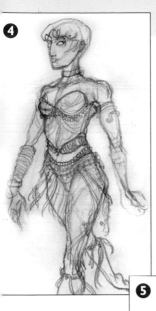

4 The dancer now has a slightly different demeanour. Her head is straighter and she has more symmetry in her movement. You can see how the clothes are doing a lot of the work, giving her a sense of movement. Notice how the right leg is drawn to suggest a controlled dance move rather than a run.

5 Here, the left hip is higher than the right, which in turn affects the positioning of the right leg.

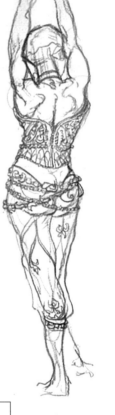

6 The body is now twisting slightly away from us; therefore, we can see more of the back of the figure at the upper torso.

SCULPTURES

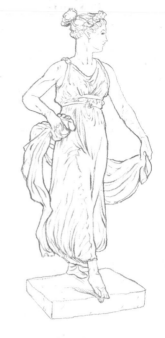

RUNNING WOMAN

We can learn a great deal from studying sculpture that depicts simple everyday activities. This statue of a running woman shows very clearly how the folds of her dress and scarf flow behind her.

TRIO

This poignant statue of a mother and father carrying their injured son has a powerful and carefully considered composition.

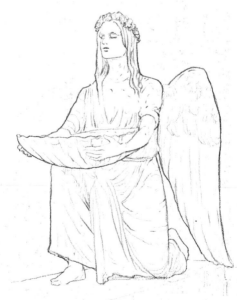

FLYING WOMAN

Epic mythological scenes, such as this flying goddess bearing a young man, are common. The extreme dynamism of the pose is well represented and the wings are perfectly crafted.

ANGEL

Classic images, such as this angel, can be a good source of inspiration for character and costume detail as well as shadow and form.

HEROINES action

DRAWING THE FEMALE IN ACTION FOLLOWS THE SAME PRINCIPLES AS DRAWING ANY OTHER FIGURE IN ACTION. IT COULD BE SAID THAT A FEMALE FIGURE IN MOVEMENT HAS A MORE GRACEFUL LINE OF ACTION THAN A MALE FIGURE, BUT THIS IS NOT A STEADFAST RULE. ADMITTEDLY, THE FEMALE FIGURE WOULD ALWAYS HAVE MORE CURVES, BUT UNDER A TONNE OF ARMOUR WE ALL LOOK THE SAME ANYWAY.

COMBAT

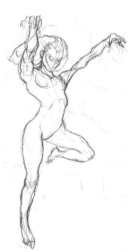

1 Draw some perspective lines and add the centre line to give an overall impression of the flow of energy – in this case, a strongly arched spine.

2 Construct a stick figure, showing the position of the limbs and the shape of the torso.

3 Add form to the body. In this case, spiralling lines have been used.

4 Refine the details of the figure. Notice how the arch of the back is emphasized. Also, the hair has been drawn in such a way as to give it three-dimensional form. The fingers and hands have been added in more detail, and the right hand and arm are foreshortened.

6 The final figure has been coloured digitally and some shadows and highlights loosely added to give a sense of form.

5 Add the clothes. See how the flow of the cloth closely follows the original spiralling effect on the rough sketch. This gives the impression that the clothes are wrapped around and flowing off the figure. Trailing ends have been added to emphasize a sense of movement.

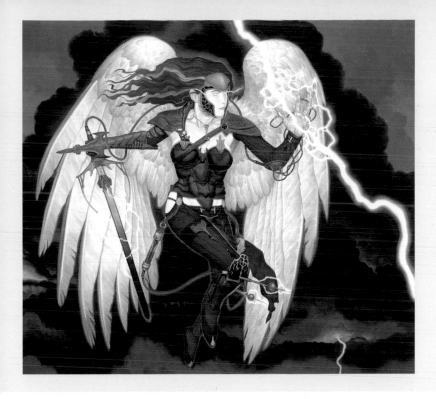

This fiery haired warrior angel holds a steady pose that suggests confidence and bravery in the midst of the maelstrom that swarms around her. Is she at the mercy of the lightning or does she control it? 'Lightning Angel', RK Post

ACTION SEQUENCE

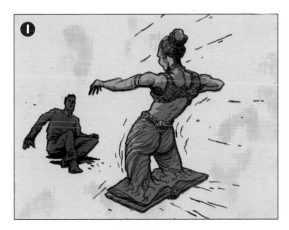

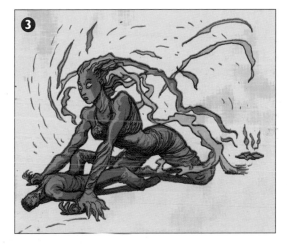

3 This leads us comfortably to the next drawing, where the viewpoint has been changed to see the genie pinning the victim to the ground. This angle allows us to see the evil intent on the face of the genie and emphasizes her gigantic size compared to the human victim.

1 This sequence shows a genie rising from the pages of an ancient book. She towers above the seated figure, who is falling backward in shock. There is no emphasis given to background detail or framing here, allowing us to focus on the action of the figures.

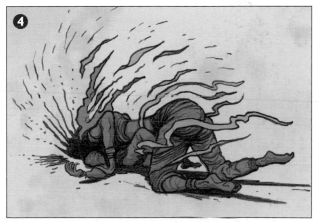

4 Finally, we switch back to the original viewpoint as the genie bites her victim's head off. The viewpoint spares us some of the grisly detail.

2 The genie leaps and we can see how the lower body is pointing directly upward but the torso is lunging forward with the arms flung back. The victim has now fallen farther backward.

goddess in the library

THIS ILLUSTRATION, DEVELOPED BY STORM THORGERSON AND MYSELF, WAS FIRST DESIGNED FOR THE STORY 'THE EDUCATION OF THE MUSE', AND THEN REVISED FOR USE ON THE ALBUM SLEEVE 'SYMPHONIC LED ZEPPELIN'. IT WAS LATER REVISED AGAIN FOR AN ANIMATION PILOT ENTITLED 'DREAM THIEVES'.

THE EDUCATION OF THE MUSE

In her youth, the muse was walking by the southern shore of the Mediterranean in a place and time unknown to her. Far in the distance she saw a mountain, wreathed in cloud. She became curious and began walking towards it. The journey took several days because the mountain was much larger than it appeared. When she finally arrived at the foot of the mountain, she discovered that it was not a mountain at all, but a great pile of books. She looked at her feet, crouched to her haunches, picked up the first book that she saw and began to read.

When she had finished the book, she placed it, neatly, tenderly, behind her and picked up the next. As she finished each book, she placed it in the growing stack behind her. She became utterly absorbed in her reading. Several centuries passed, but time had no meaning in this place. As she continued to read, book after book, she built a great palace of books around her. Great vaulted ceilings, buttressed walls and ornamental arches gradually evolved from the fruits of her studies, all built entirely from the huge volumes that she lovingly devoured.

These drawings depict the conclusion of the goddess's education. She has reached the final page of the final book: the source of the fountain itself, the starting point of all knowledge. The page is blank, save for a single dot in the centre. It is the dot from which sprang the first line, the line that became the first letter of the first word, which then grew into a paragraph and thenceforth into every recorded utterance of humankind, throughout time, in eternity. This is shown in the illustration by the position of the dot. It is aligned to the single vanishing point of the whole image – the physical source of the image – as well as to the tip of the goddess's spine, the sacrum bone, the residing place of the soul.

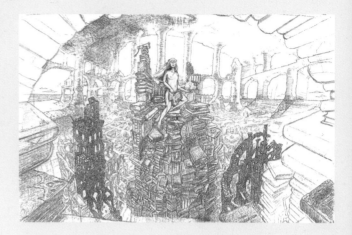

1 The original study was an attempt to show the vastness of the library by experimenting with ways of making the columns look as large as possible but still suggest they were made from books. This drawing uses three-point perspective (see pages 82–83).

2 The waif-like goddess in the first study did not seem suitable, so we experimented with different types of female figures. Here, a stronger, more symmetrical woman has been used.

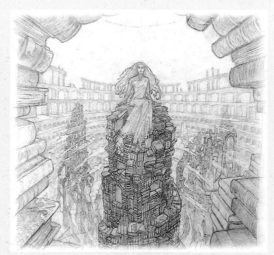

3 The idea of a strong goddess-like figure was compelling and led to this image of the classic 'white goddess' of Celtic and Roman myth (her many incarnations include Astarte and Isis). The background was refined to a one-point perspective, which increased its symmetry and impact.

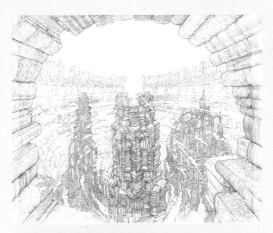

4 When the image was chosen for the album sleeve, it was redesigned to fit the square format and the arch was widened. The entire background was redrawn in a clean pencil line and the height of the tower of books in the foreground was increased.

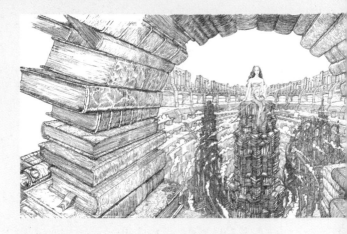

5 The figure was drawn much larger on a separate canvas so that it could be scaled down but still retain detail. The artwork was then digitally photographed on a rostrum camera and delivered to the retouch artist, Jason Reddy.

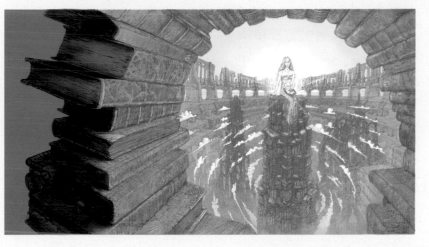

6 Jason Reddy, who specializes in computer retouching but is also an accomplished hyper-realist oil painter, finalized the digital images from which colour transparencies were produced. A green colour palette was eventually chosen.

7 Afterwards, I began to feel that there were three flaws in the artwork. The first was that it didn't scale down to the size of a CD very well, which I should have considered, but the poster version looked great and no one seemed to mind. The second flaw was the colour, which I had always envisaged as a desert palette to suit the location in the original story. Finally, I still wasn't satisfied with the figure, which had looked fine on its own but didn't gel with the background. When the idea was selected for an animation pilot, I revised the colours and added a new figure.

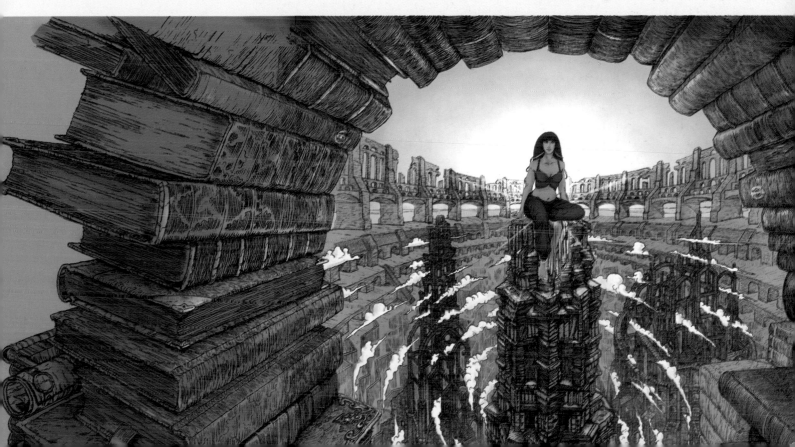

WIZARDS faces

GNARLY OLD MEN WITH SHAKESPEAREAN VOICES HAVE BECOME A FORCE TO BE RECKONED WITH IN THE GLAMOROUS WORLD OF FILM AND TELEVISION. IN AN AGE OBSESSED WITH YOUTH AND BEAUTY, THE OLDIES HAVE COME BACK FIGHTING AND, THANKS TO DIGITAL SPECIAL EFFECTS, THEY CAN DO ANYTHING THEIR YOUNGER COUNTERPARTS CAN, BUT WITH BETTER ACTING SKILLS.

AGE EFFECTS

DRUID

1 These drawings show how to simulate the effects of ageing. This young man has clearly defined cheekbones and jaw and his eyebrows are dark.

2 Now, look at the same character in old age. Obviously, his hair has slipped to around his jaw, but we can see also that his eyebrows have become bushier. The ears and nose continue to grow throughout our lives, so they are comparatively larger, and the nose also has a bolder shape.

JEDI

1 This example shows a young Jedi type. He has smooth skin and a strong, clean jawline.

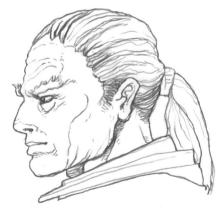

2 As he grows older, his eyebrows thicken and his nose and ears get larger. He has crow's feet at the corners of the eyes and bags under the eyes. The flesh tends to be much more defined in old age, so you can add more lines, the cheekbones becoming more clearly marked. It can be difficult to add lines around the nose without making the character look miserable – it's a matter of experimentation.

3 Alternatively, you could always just give him a hood, which will imbue him with an aura of mystery.

ARCHETYPES

COMEDY WIZARD

This wizard seems to be a wandering fool, perhaps a scatterbrain. He wears the robes of a desert dweller or nomad and his identity is characterized by his peculiar tricorn beard.

MAD MAGICIAN

This wizened old figure has given up all worldly things (even his clothes) and lives the simple life as an ascetic in search of enlightenment. He is based on the real-life figure of Hassan I Sabbah, who masterminded a reign of terror from his remote Persian castle in the 11th century. He had his own son executed for drinking wine, and the word *assassin* is derived from his followers. He was, however, not known for prancing about naked.

EVIL SORCERER

This wizard is clearly a villain and seems to have a Russian feel about him, like Rasputin. His clawlike fingers give him a threatening appearance and his glaring eyes suggest he has hypnotic powers.

Left: This computer game character makes a striking impression, partly due to his enormous horned headgear and extravagant cloak. *'Plague Witch', Martin McKenna*

Above: An intense stare suggests deep concentration. The wizard's clear eyes mark him as intelligent, but is he good or evil? *'Diabolist', Martin McKenna*

OVER TO YOU

■ *Choose one of the heroes that you created when doing the exercises on pages 20–31. Apply some age effects to him, aiming to create a typical wizard, such as Merlin or Mordred from Arthurian legend.*

■ *Now look for inspiration for a very different kind of wizard by reading about the medicine men of North American Indian culture, the witch doctors of Africa, and the sages and prophets of the Far East. Use this information to transform your hero into a different type of wizard, then compare both of your creations.*

WIZARDS beards

IN THE WORLD OF FANTASY ART, NO
WIZARD, MAGUS, SAGE, PROPHET OR
SEER IS COMPLETE WITHOUT A BEARD.
ANY MALE CHARACTER OVER THE AGE
OF FORTY MUST HAVE ONE ...

... and the occasional female, too, come to
think of it. Beards are a cast-iron indicator of
power, wisdom, perspicacity, fiendish cunning
and a host of other essential attributes in a
fantasy character, but it has to be the right
beard, and it has to look convincing. There are

two ways you can ensure that
your beards look the part. First,
give them mass or volume – make
them an object. Second, try to
give them personality. Beards
are a form of costume and
can be used to express powerful
symbolism. On the opposite page
we'll try an experiment, drawing
some different beards on the same face and
imagining what kind of character would wear
which beard. It's amazing what transformations
you can bring about with a bit of facial hair.

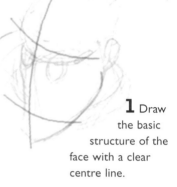

1 Draw
the basic
structure of the
face with a clear
centre line.

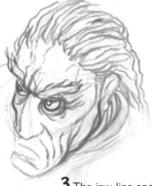

3 The jaw line and
mouth are added at this
stage, even though we won't
see them in the finished
drawing. Don't forget the
wild eyebrows.

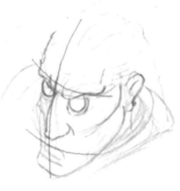

2 Start to add
essential features.

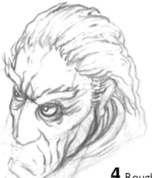

4 Rough in
a solid shape
projecting from
the line of the chin.
Add some lines to
show its form. The
sides of the beard go all
the way up to the ears.

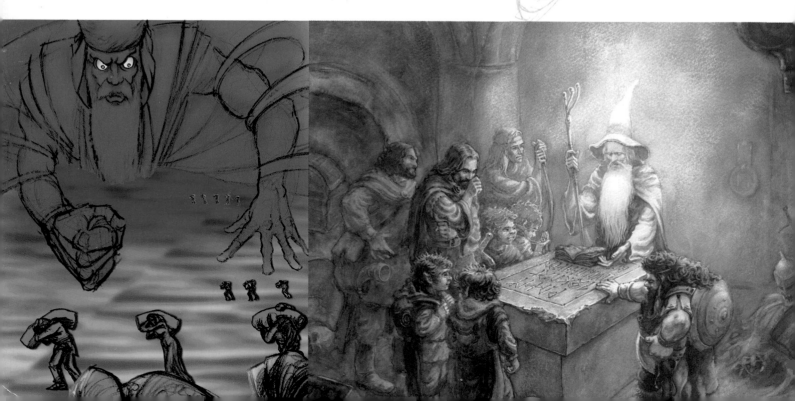

5 Draw in the moustache as a separate 'object'. In this case, it's like a crescent moon that wraps over the top of the beard.

6 Break up the outside line of the beard with an eraser and add detail to the hair as it splits. Add some shadow underneath the moustache and work into the overall texture with a fine eraser. Go back and forth between pencil and eraser to create a soft, natural look.

BEARD LORE

THE CHALLENGER

A beard with strong definition, suggesting seriousness of purpose – a good choice for scientists, explorers and high-ranking wizards.

THE DRUID

So named due to its popularity with druids and other pagan priests, this beard is easy to manage and reveals a keen sense of imagination.

THE SULTAN

This style requires much grooming and is usually sported by sultans, who have time on their hands, and by megalomaniac viziers, who tend to be extremely vain.

THE SHOCKER

Popular in ancient times among the druidic fraternity, the shocker has long since fallen out of favour. It is now worn only by younger druids as a sign of rebellion. It is also seen on mad monks, wandering holy men and dervish ecstatics, as it requires little or no grooming.

OVER TO YOU

■ A beard is not an automatic choice for the centre of a composition, but it can be an extremely effective starting point. Choose a beard (or other facial characteristic) and create a composition around it.

■ Think about what type of beard it is and what it symbolizes. Is it good or evil? What is it saying to the reader?

Left to right: Three different wizards, three different beards – straight and short (for a wizard, anyway); long, flowing and natural; and a tricorn style favoured by druids. 'Magus', Finlay Cowan; 'The Great Loss', Alexander Petkov; 'Vizier', Finlay Cowan

WIZARDS costume

THE CLASSIC WIZARD ARCHETYPE IS PROBABLY GANDALF, WHOSE LOOK HAS EVOLVED FROM CELTIC DRUIDS AND WANDERING MONKS. ALTHOUGH WIZARDS TEND TO STICK TO ROBES AND CLOAKS AS THE PREFERRED FORM OF DRESS, THEY HAVE THE WIDEST RANGE OF ACCOUTREMENTS OF ALL THE FANTASY ARCHETYPES. FROM SPELLS AND TALISMANS TO POTIONS AND ELIXIRS, A WIZARD IS PREPARED FOR EVERY EVENTUALITY.

SKULL STAFF

Small animal skulls and teeth can be lashed to the staff and, with the right incantation, can raise the dead or give the wizard the power of the animal in question. Human skulls are a bit unwieldy and are generally used only by ogres, cannibals and she-devils.

STAFF

No wizard, mystic or seer is complete without his staff. Its primary use is as a walking stick for those long, drawn-out quests, but it also comes in handy as a weapon for fending off roadside bandits and bringing argumentative teenage sidekicks into line. I chose a large undecorated wooden staff for this drawing of Gandalf, to symbolize his very powerful and earthy personality.

CRYSTAL STAFF

The addition of crystals, stolen from a dragon's lair, can provide the wizard with a variety of useful tricks, such as the ability to fly or become invisible.

SYMBOL STAFF

Staffs carved in the shape of a powerful magical symbol are very popular. The symbol can denote membership of a particular order of wizardry or show allegiance to a specific demigod. The staff can be used to invoke the power of the demigod, usually an elemental force such as rain, thunder or a plague of frogs.

OVER TO YOU

■ There are plenty of books of signs and symbols available. Look for a symbol that you think would be suitable for a wizard.

■ Draw a variety of different objects that a wizard might carry and try to incorporate the symbol into them in different ways.

A treasure trove of kabbalistic ephemera has been created digitally for this image of a sorcerer's study. 'The Wizard Chamber', Bob Hobbs

ACCOUTREMENTS

Potions, with uses ranging from raising the dead to curing common colds.

Spells inscribed in ancient languages that are indecipherable to the uninitiated.

Keys to various chests, hoards and secret chambers.

Hand of Fatima to avert the evil eye.

Eye of Osiris, or the evil eye, to cast bad luck.

Powder pouch for creating impressive special effects.

Logo to identify the order or sect to which the wizard belongs – the middle-earth equivalent of a designer label.

Rings to enhance powers, represent the wearer's authority and use as a seal.

Herbs and spices – the use of natural remedies is widespread among wizards.

SYMBOLIC OBJECTS

SERPENT RING

The ourobouros, or serpent eating its own tail, represents the eternal cycle of nature, while the ring itself symbolizes the path of the sun around the heavens.

SPELL BOOK

Where would a wizard be without a mouldering tome? Most books have special powers of their own – they can speak, they can fly, they can open the gates of hell – but if that doesn't work, the book should be hefty enough to use as a blunt object.

SPELLS

Spells can be cast verbally or inscribed. This one is called *abreq ad habra.* It calls down the 'thunder that kills' and is the origin of the common phrase *abracadabra.* It is also said to be a blessing, and it is important that the letters are written in the form of an inverted triangle.

HAND OF FATIMA

The four fingers represent generosity, hospitality, power and divine goodness.

WAND OF HERMES

Also known as the caduceus, this is a symbol of peace, protection and healing.

PENTAGRAM

The five-pointed star is used to bind or entrap the powers of evil.

INSCRIBED RING

From the earliest times, the ring has symbolized eternity and the creation of bonds. Very ancient rings are inscribed with incantations or the signs of the zodiac.

WIZARDS powers

WIZARDS USE EITHER ELEMENTAL POWERS OR SPELLS WHEN DOING BATTLE. BEING INITIATED IN THE SECRETS OF NATURE, THEY CAN CALL ON WIND, RAIN, FIRE AND EARTHQUAKES TO ASSIST THEM WHEN DISPATCHING SUNDRY BEASTS AND VILLAINS BACK TO THE NETHERWORLDS WHENCE THEY CAME. ALTERNATIVELY, THEY WILL USE SPELLS ACCOMPANIED BY ELABORATE HAND SIGNALS.

LIGHTNING

1 Begin by sketching a few overlapping lines, as you would when drawing cloth or hair.

2 Trace them onto another piece of paper, giving each bolt its form and shape.

3 In this example, simple digital effects have been applied. There is a stark contrast between the lightning and background, and the lightning has been enhanced with an outer glow. You could apply the same effects using paint.

BILLOWING SMOKE

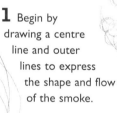

1 Begin by drawing a centre line and outer lines to express the shape and flow of the smoke.

2 Add a series of overlapping circles of varying sizes. Add a few trailing lines.

3 Draw in the hard lines, exploring the shape of the smoke, and consider how each billow overlaps the others. Here, a simple texture has been added digitally. Shadows around the edges of each billow and a small highlight on the upper side of each one enhance the form of the smoke.

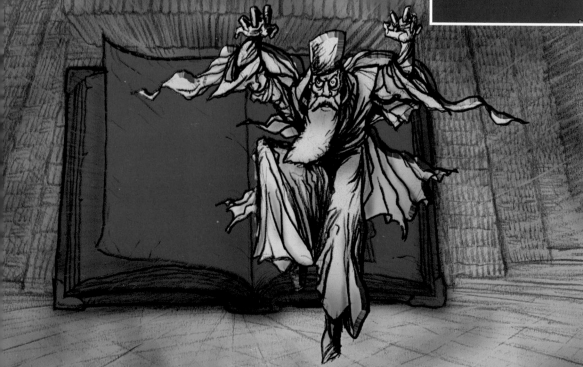

This evil wizard appears to be jumping out from the pages of a book. His claw-like hands make it clear that he can unleash great and terrible powers.
'The Scapegoat', Finlay Cowan

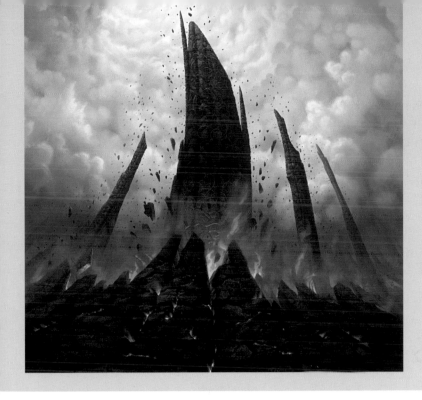

OVER TO YOU

■ *Working purely in black and white, create some cloud and lightning effects. Cover large areas with grey tone, then use an eraser to create highlights.*

■ *Now experiment using paints, which require a similar process of building up depth with light and shadow.*

■ *Do the same with digital effects. Compare the different results.*

Elegant and detailed cloud and fire effects have been carefully combined in this painting of a cataclysmic event. *'The Rebirth'*, Christophe Vacher

WHIRLING SMOKE

1 Smoke and cloud forms can be twisted and modified for any use. Draw a simple spiral and roughly add a series of clouds on it.

2 Add a second set of clouds, this time spiralling in a different pattern and overlapping the first series of clouds.

3 Trace a clean version of the final drawing, making sure that the overlaps are consistent. Again, you can apply simple digital or paint effects to enhance the drawing.

HAND GESTURES

DEVIL'S HORN

When the hand is clenched with the first and fourth fingers extended, it is called the devil's horn. It is probably meant to represent the horns or crescent moon of the Egyptian goddess Isis and is a protective sign against evil.

AGAINST EVIL EYE

A clenched hand with all the fingers closed and the thumb between the first and second fingers is a common symbol in Etruscan tombs. It is used for protection against the evil eye.

GOOD LUCK

This gesture was used by the Canaanites, one of the numerous heretical sects of 2nd-century Egypt. Note that the fingers must be inscribed with the right tattoos for this gesture to work.

BEASTS dragons

'HERE BE DRAGONS...' THIS CLASSIC LINE CAN BE FOUND ON OLD MAPS TO DESCRIBE UNEXPLORED AREAS INHABITED BY UNKNOWN CREATURES. SINCE TIME IMMEMORIAL, THE IMAGE OF THE DRAGON HAS APPEARED IN ALL CULTURES AND LEGENDS, AND IT STAYS WITH US TODAY AS A MAINSTAY OF THE FANTASY GENRE.

Dragons clearly have their origins in early sightings of huge serpents, crocodiles, komodo dragons and sea creatures. In the West, the dragon usually represents evil and is a symbol of greed and selfishness. It hides away under the earth to protect its treasure and the occasional princess. The Chinese dragon, however, represents wisdom and the bounty of the waters. It is commonly pictured with a pearl in its mouth, which is said to be the source of its power, and the dragon is tamed if the pearl is taken from it.

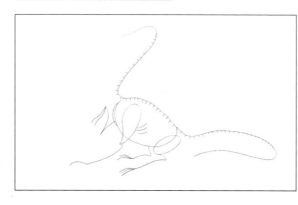

1 Draw a few rough sketches to help you decide on the general proportions of your dragon. Here, I have concentrated on the basic structure and the flow of the spine, which was inspired by dinosaur skeletons.

2 Try drawing the basic shapes in three dimensions, using perspective lines to guide you (see pages 80–83).

3 Now the real work begins, where you build on your studies to refine your dragon in a new drawing. In this case, the shape of the neck and the angle of the head have been altered to give the pose more dynamic tension. These refinements are only possible because you are building on a series of roughs that help you get to know the pose.

4 Trace a new, clean drawing and add the final detail. (You could work on the original drawing, but you'll need to do a lot of work with an eraser.) Try to develop a systematic, consistent style of adding scales (see panel). The scales on this dragon were inspired by crocodile skin; the spine was inspired by crocodile bones.

DRAWING SCALES

Scales, bones and skin effects are created by building up a series of layers of different shapes. You can achieve good effects by systematically repeating various overlapping forms – a simple method to produce a complex result.

5 Colour your final drawing. This example was coloured using Photoshop, but the basic principles of colouring scales apply to any medium (see page 60).

1 Begin with a single line of repetitive shapes.

2 Add a second layer, this time using a different shape.

3 Continue in this way until the desired pattern is achieved.

4 In this example, the first line of repetitive shapes forms a spine. This evolves into large scales across the flank, before gradually fading into smaller scales.

5 When applied to a three-dimensional beast, remember to take the curves of the body into account. Applying the detail in the right way can emphasize the shape of the body.

A fluid and energetic sketch is developed into a refined painting that still retains the energy and character of the original. Note that the left arm of the dragon has been changed to incorporate a figure in its clenched claw.
'Bazil', David Spacil

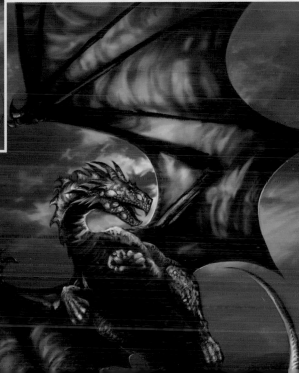

OVER TO YOU

■ *Look at bones and skeletons in museums and reference books. Crocodiles and T-Rex skeletons are obvious sources of inspiration for dragons, but giraffes and horses can also provide outlandish and interesting forms that can be applied to fantasy beasts.*

■ *Choose two very different animal skeletons and use them as the basis for developing two very different dragons.*

BEASTS mega monsters

MONSTERS SUCH AS THE BEHEMOTH AND ZARATAN FORM A CATEGORY OF THEIR OWN BECAUSE OF THEIR SCALE. THEY CAN BE THE SIZE OF BUILDINGS, MOUNTAINS, ISLANDS ... EVEN PLANETS. THEY ARE PARTICULARLY POPULAR AMONG JAPANESE MYTHMAKERS, WHO HAVE CREATED A NEW GENERATION OF OUTSIZE HEROES TO STOP THESE MEGA MONSTERS FROM TROUNCING TOKYO.

Creating such beasts is an interesting process. You can look to the same sources of reference as you would for any fantastic beast, but ultimately it is the way the creature is placed in the environment that gives it its impact (and in some cases, the monster *is* the environment). The artist must choose carefully what to place around the creature in order to emphasize its vast scale. First, foreground objects must be tiny, and this presents problems with the amount of laborious detail required. Second, the use of extreme foreshortening can do a great deal to enhance the presence of the creature.

The behemoth is the original giant monster. It is described in the Bible's Book of Job and is generally depicted as a magnification of an elephant. Several other descriptions through the ages have given it metallic cladding and protective spikes. The zaratan is a giant sea turtle that features in numerous stories, such as those of Sinbad. The basic tale is of a group of sailors who land on an island that then sinks, drowning them, because it was a living creature.

BEHEMOTH

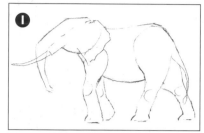

1 The obvious starting point is to make a rough sketch of an elephant. You can trace the outline from a photograph.

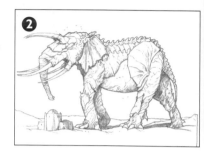

2 Add detail systematically using a series of embellishments. In this example, the ears were inspired by bats, the scales by snakes and crocodiles, and the armour plating at the top of the hind leg by a snail shell. Add shadows beneath the armour so that it appears to stand out from the body slightly.

3 Colour the finished drawing. The same rules for colouring scales apply whether you are using paint, pencils or a computer (see panel below).

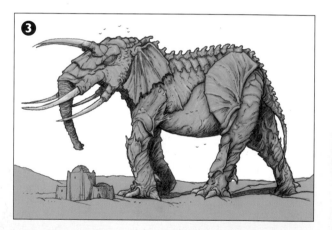

COLOURING SCALES

This technique, which you can use for colouring any type of object, relies on a systematic approach. You can apply it digitally or with paint, coloured pencils or pastels. It doesn't work with felt-tipped pens because they don't blend well.

1 Complete your line drawing, then add a single colour over the whole drawing (beige in this case). Keep it as consistent as possible.

2 Add a shadow under every single line of your drawing. That's right – every single scale, crease and dot must have a shadow beneath it. Be consistent, working from one end of the drawing to the other.

3 Do the same with highlights, adding a lighter colour above every single line. Again, be consistent and systematic. It's a laborious process, but it can be very therapeutic if you learn to be patient.

4 Blend the colours. If you are using pastels or paint, simply smudge them with your finger or add more paint. If you are using coloured pencils, go back over the colours with the original background colour to help soften the blends.

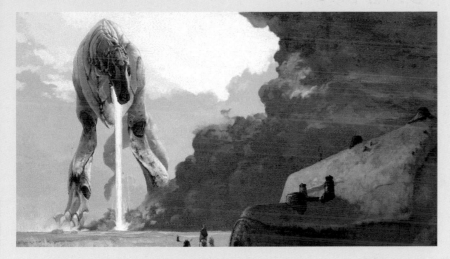

A masterclass in composition. The foreground figures are tiny, which emphasizes the vast scale of the beast from whose mouth the fire seems to drop like a waterfall. The greater area of the picture is taken up by a vast cloud of smoke. 'Pharaoh Hound', Anthony S Waters

OVER TO YOU

■ Visit a zoo or aquarium and take some reference photographs of various creatures.
■ Experiment with making hybrids of these animals, playing around with the possibilities of crossbreeding creatures to the best effect.
■ Add environmental details that emphasize the creature's scale.

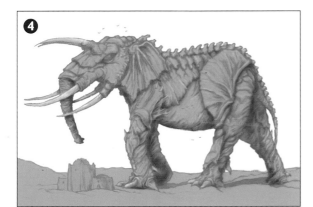

4 Here, the original pencil lines have been blended into the colours to soften the image. This was done digitally, but it can also be achieved with paints, coloured pencils and pastels.

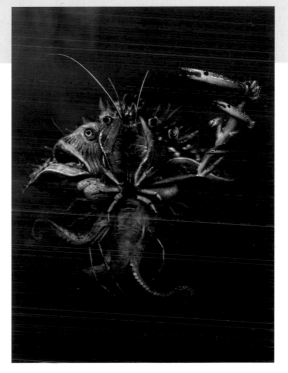

ZARATAN

1 Make some preliminary studies of turtles. I was fascinated by the turtle's shell and its hard, bony head, which seems primordial and could be scary if it were enormous.

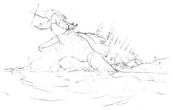

2 Make a sketch to help you define the composition of the drawing. You might need to try a few different angles and elements before you are satisfied.

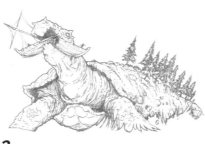

3 Add the detail in the same way as you did for the behemoth, using the bony head, leather neck and tough shell of the turtle as reference. Add the sea, boat and landscape.

4 Colour and blend the pencil lines in the same way as for the behemoth.

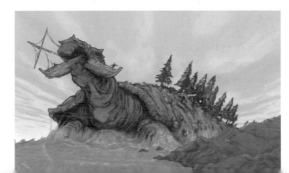

This album sleeve features a mythical sea monster composited from existing sea life … a kind of Frankenfish, if you like. A drawing was made using reference photographs taken at aquariums. Once the design had been approved, a photographic unit was despatched back to the aquariums to photograph the relevant parts from the right angles. Finally, the photos were composited digitally, using the original drawing as a guide. 'Ween', Storm Thorgerson, Finlay Cowan, Sam Brooks, Jason Reddy & Peter Curzon

BEASTS horses

HORSES APPEAR THROUGHOUT FANTASY ART AS TRUSTY STEEDS FOR ERRANT KNIGHTS OR AS THE DEMONIC CARRIERS OF DEATH PERSONIFIED. PROPORTION IS A KEY FACTOR IN ACHIEVING A GOOD LIKENESS AND, AS A GENERAL RULE OF THUMB, THE HORSE'S BODY (FROM SHOULDER TO TAIL) IS ABOUT TWO-AND-A-HALF TIMES THE LENGTH OF ITS HEAD.

HEAD

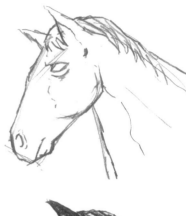

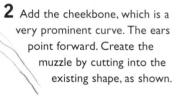

1 The shape of the horse's head is almost triangular. The nose is slightly curved and the head is supported by a thick neck. The shape of the head can vary considerably, however, depending on the variety or breed.

3 Add the eyes, mouth and nostrils. The eyes can be difficult to get right and you may have to try several times before you get something that looks good. The tiniest variation in their size and position can make an enormous difference to the way the creature looks.

2 Add the cheekbone, which is a very prominent curve. The ears point forward. Create the muzzle by cutting into the existing shape, as shown.

4 Add some shading, using it to pick out a bit more detail. The horse's muscle is quite thin on its head, so more of the bone structure tends to show through.

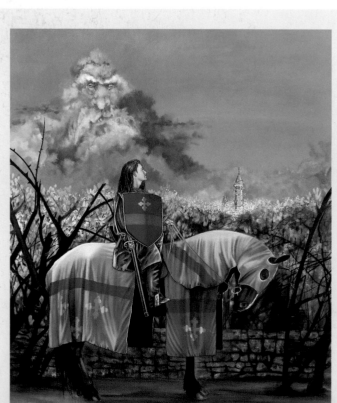

OVER TO YOU

■ Draw a horse's head. Instead of focusing on shading techniques, try putting a dappled pattern on the head.

■ Alternatively, go completely black with a few highlights. Try to find different solutions to problems you might have.

This horse, clad in simple but elegant cloth, will surely be the envy of the stables. With its arched neck and steady pose, it is the perfect steed for the princely rider, who is about to enter the forest of thorns in search of the Sleeping Beauty. 'Prince on Horseback', Carol Heyer

BODY

SKELETON

The shape of a horse is easy to construct. It has a large ribcage that can be defined by drawing an oval. The spine and tail form the curving shape of its back. Notice how the shoulders and hips are particularly large, and how the hooves angle away from the leg.

MUSCLES

This drawing shows the basic musculature of a horse. Being aware of muscle placement can be very useful when it comes to adding detail and drawing horse-type creatures.

SHADING

Add tone to the horse by roughly following the lines of the muscles. This is often not necessary because you will more than likely be adding chandlery such as saddles and so on, or body armour.

ARMOUR

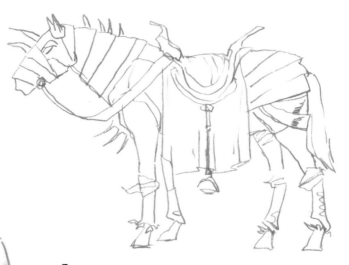

1 Armour has been added to this horse in the same way that a human is armoured (see pages 72–73). The series of plates follows the curves of the body and a blanket has been thrown over the horse's midriff with a saddle on top. The saddle has ornamental pommels front and back. Armour has been added to enhance the horse's knees and ankles.

2 Shade the armour and add some ornamental spikes on the forehead, neck, chest, knees and hooves. The parts of the horse that are visible are almost entirely black, saving the need to delineate muscle shape. The saddle has a cracked, leathery look and the plates of armour have some simple highlights that make them look more metallic.

64

BEASTS horses and hybrids

DRAWING HORSES IN ACTION IS JUST A MATTER OF FOLLOWING THE SAME
PROCESS THAT YOU USE WITH HUMANS. IT IS IMPORTANT TO CREATE DYNAMIC
IMPACT WITH YOUR CREATURES AND USE THE COMPOSITION OF YOUR DRAWINGS
TO SHOW YOUR SKILLS TO THE BEST ADVANTAGE. THE HORSE CAN ALSO BE USED
AS A BASE TEMPLATE FOR NUMEROUS OTHER CREATURES.

GALLOPING

1 You can get a good idea of the dynamics of a moving horse by sketching just a few rough lines. This will give you a sense of movement and drama without having to think about proportion and detail too early in the drawing.

2 Add the general shape of the body, head and limbs. Rework the drawing as necessary in order to improve the proportions. This may involve a lot of erasing and redrawing. Try not to get involved in detail at this stage. Just make sure the knees are in the right places and the body parts are in proportion.

3 Add detail such as armour. I've also added a nose guard with a spike that sticks out like a horn, following the line of the neck. This adds extra drama and tension to the forward thrust of the horse's movement. Notice how the blanket is flying backward in the wind. I have left the hooves vague to suggest the dust being kicked up as the horse gallops. I drew in the figure at the end — a small demon type who seems to suit the evil look of the beast it is riding.

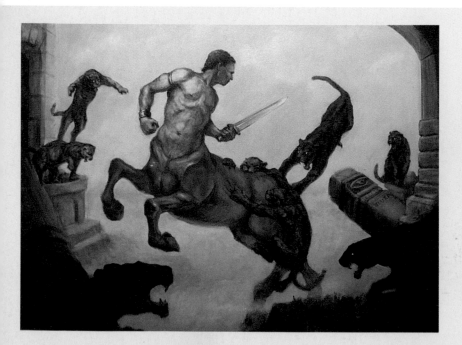

OVER TO YOU

■ *Try to create some interesting animal/human hybrids. What would a horse look like with two tails or one eye? How would it look if it were covered in spines or fur? What about a horse covered in fish scales with lots of fins?*

■ *Develop some stories for the new creature. What is its history? How was it born and how does it die? Is it good or evil? Does it have special powers?*

This classic rendition of a centaur beset by a pack of well-observed panthers displays excellent use of composition, foreshortening and twisting.
'Centaur Attacked', Stan Wisniewski

HORSE HYBRIDS

CENTAUR

The centaur is one of the most famous hybrids of Greek mythology. It consists of a horse's body with the torso of a man beginning where the horse's neck would have been.

CROC HORSE

Here, I have grafted the skull of a crocodile onto the body of a horse. The neck, shoulders and lines of muscles have the scaly, leathery look of reptile skin. The beast is completed with some horny fringing on the backs of the legs, dinosaur feet with stubby claws instead of hooves, a long, spiny tale and a couple of horns on the hips for extra flair.

HORSE DEMONS

I drew these highly stylized versions of horse's heads for use as demons. They don't stay true to the look of a horse, but it's clear that the horse was the original inspiration before I added pointy ears and horns.

PEGASUS

Pegasus appeared in Greek mythology. He was the winged stallion that sprang full-grown from the blood spurting from the snake-haired Medusa's neck after she was beheaded by the hero Perseus.

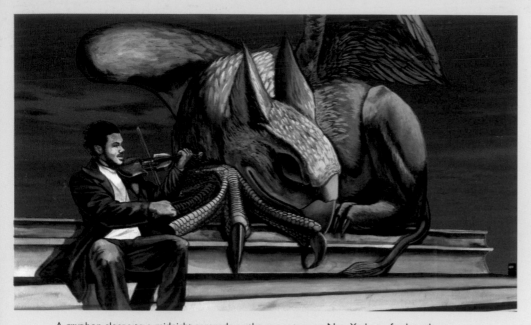

A gryphon sleeps to a midnight serenade as the sun sets over New York – a fresh angle on an ancient myth. 'Gryphon at the Met', Theodor Black

OVER TO YOU

■ Natural history museums are full of useful bird specimens that don't fly away when you try to draw them. Choose a species and study its feathers, observing how they lie on different parts of the body.

■ Draw close-up sketches of each type of feather and practise colouring them. Blend the colours really well on soft, downy feathers but retain more detail on larger, sturdier ones.

BEASTS other creatures

IN ADDITION TO THE HORSE, THE FANTASY WORLD IS INHABITED BY A WIDE RANGE OF OTHER CREATURES THAT USUALLY LIVE IN THE REAL WORLD. THESE MAY BE DEPICTED REALISTICALLY, LIKE A WISE OWL (THOUGH IT CAN PROBABLY SPEAK), OR GIVEN A TWIST OR FLOURISH SUCH AS AN EXTRA PAIR OF HEADS.

The owl is not a mythical beast but it is, nevertheless, a creature with tremendous symbolic powers. In medieval times, owls were feared as a portent of doom, but nowadays they represent wisdom. Birds can be difficult to draw, and owls are so strange looking that they can be infuriating. Their enormous eyes and delicate feathering require careful observation and attention to detail. Cerberus is the ultimate watchdog, guarding the gates of Hades. Said by the Greek poet Hesiod to have 50 heads, Cerberus has been more often depicted with a more manageable three, which are said to look to the past, present and future.

OWL

1 The owl's head is flat, oval shaped and large in relation to the body. The legs are solid looking because they are covered with thick feathers. Notice the frowning expression created by the two strong diagonal lines over the large eye sockets. Try a few different structural drawings like this one until you get the proportions to your satisfaction.

2 Notice how the breast area has a well-defined central line. I chose a composition with the head turned away from the central line and the owl's left wing wrapped forward across the breast. The right wing seems a little hunched and the right leg is higher than the left – these minor details lend more character to the figure.

3 The central line on the owl's chest provides a guide for the feathers, which all point towards it. Feathers vary a great deal, depending on which part of the anatomy they grow, so you have to develop techniques for drawing each type of feather, which is not easy. Keep the line work soft, in keeping with the soft texture of the feathers, and allow for subtle shadow work.

CERBERUS

1 I used a bulldog as the model for Cerberus. Notice its wide-legged stance, which gives it a defiant air and a solid rooting to the earth. It's hard to fit three heads onto one body. Start by drawing three circles on the forequarters to provide the starting points for the necks and then work outward to the heads.

2 Once you are happy with the proportions, begin to add details, including the ears, eyes, and pugnacious mouths.

3 Add skin and muscle detail to the drawing. You can take the same approach for muscles as you would with human anatomy. Add extra detail around the necks to help them sit better visually on the body.

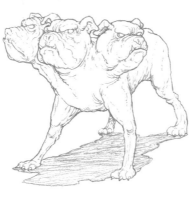

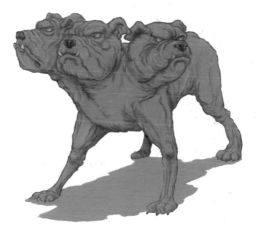

4 Colour the final drawing, giving special consideration to the shadow areas beneath the heads and on all the underside areas.

4 Colour the finished drawing. You can colour feathers using the same method as for colouring scales (see page 60), but with a lot more blending because of the softness of the feathers. If you lose too much detail during the blending process, add it in again afterwards with a dark pencil.

This image for an album sleeve was produced using 3D modelling software called Bryce. The creature is basically a snake but look closely at the skin. It seems to be made of stone, wood, glass and water, showing that there are no limits to what you can achieve when you let your imagination go. 'The Kadusa', Nick Stone

MAN BEASTS orcs and trolls

ORCS AND TROLLS USUALLY WORK IN A GROUP TO FORM AN ARMY OF DARKNESS, A BARBARIC UNDERWORLD HORDE UNDER THE COMMAND OF AN EVIL LEADER, MAGICIAN OR DEVIL. THEY SYMBOLIZE A TOTAL LOSS OF CIVILIZED BEHAVIOUR AND INTELLIGENCE. THEIR FORMS CAN BE USED AS THE BASIS FOR A WHOLE RANGE OF DEMONS, GOBLINS AND OGRES.

TROLLS

1 Basically, trolls are the gorillas of the fantasy world. This illustration shows the difference between a human skeleton and a gorilla skeleton. Notice that they are the same height but the gorilla skeleton is much wider in proportion to its height. The arms are also proportionately much longer and the pelvis is massive.

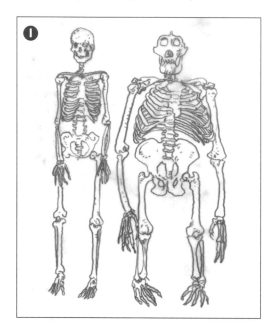

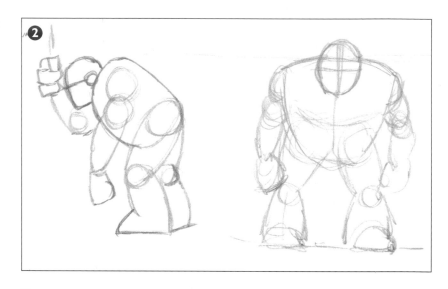

2 The head shape is drawn low, beneath the shoulder line, which gives the figure a permanently hunched look. Imagine a gorilla, only far less intelligent. The hips are slung towards the back of the body and the legs are strong and thick, giving the figure a solid stance.

OVER TO YOU

■ Look at a number of different skulls in animal encyclopedias or on the Internet, such as a fish skull, a dinosaur skull, a reptile skull or a bird skull. It's easier if you can find one that's already the right size. If not, resize it on a photocopier or computer.

■ Using the same source image, develop several different variations. This will help you build up your own graphic language of character and costume details.

The soft focus and layering of textures imbue this figure with an eerie menace that retains a strong sense of mystery. 'Alien Hamlet', David Spacil

ORCS

1 Orcs are far more birdlike or reptilian in their appearance than trolls. The face is long like a bird's and the ears are also long and pointy.

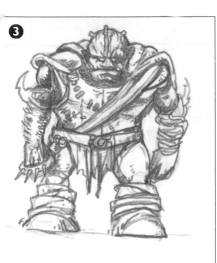

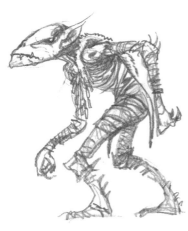 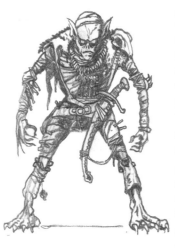

3 The costume of these despicable creatures tends to consist of a basic underlayer of rags and pieces of stitched leather over which is added a few pieces of body armour such as metal shoulder and knee pads. Ornamental details consist of jewellery made from bones and teeth or the occasional skull. The whole outfit tends to have a handmade look. The aggressive appearance is enhanced by the addition of spikes on the armour.

2 You may find that their eyes work best without pupils, just orbs of light with dark rings around them that suggest they are sunken and hollow. This seems to symbolize a lack of soul or compassion. Alternatively, you can give them snake eyes or tiny black points to make them look less human. An orc's costume consists of the same filthy rags as that of trolls.

BASE SKULLS

It can be easier to create a character if you have a strong base on which to build, such as a skull or skeleton. These two drawings of skulls – a pig's skull and a skull of early man – came from digital photographs taken at a museum. The photographs were printed out and traced on a lightbox. They were then traced again, this time turning them into characters.

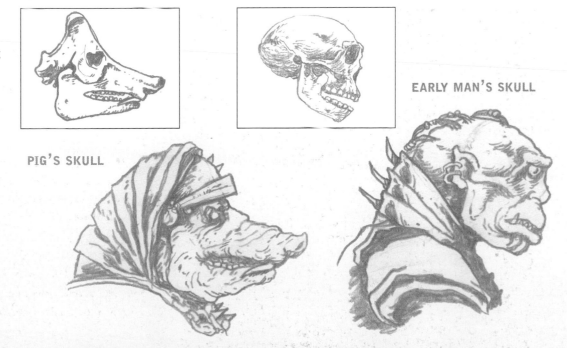

PIG'S SKULL

EARLY MAN'S SKULL

MAN BEASTS hybrids

A GOOD WAY OF CREATING INTERESTING CHARACTERS IS TO READ ABOUT MYTHICAL BEASTS IN BOOKS, THEN TRY PIECING THEM TOGETHER BY TRACING PHOTOGRAPHS OF ANIMALS AND ADDING THE MISSING PARTS. YOU WILL BE SURPRISED BY SOME OF THE RESULTS AND WILL PROBABLY PRODUCE THINGS THAT YOU WOULD NOT NORMALLY HAVE CONSIDERED.

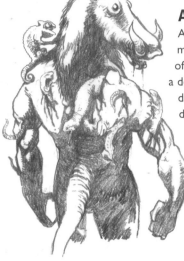

AUNYAINA

Aunyaina appears in the myths of the Tupari people of Brazil and is said to be a demon from the earliest days of creation. The description of lizards crawling like maggots in and out of his broken flesh led to this gruesome image.

BEELZEBUB

The name Beelzebub is said to mean lord of the flies. I took the translation literally and traced several images of flies. I then composed them into one grotesque collage and added them to a human body. The legs are short and stocky to enhance the demonic appearance.

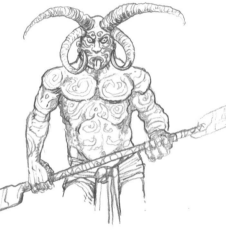

BOSSU

In the voodoo myths of Haiti, the bossu is a huge horned man. I found an interesting photograph of a ram with four horns, traced it and then grafted it onto a human head. I added facial and body tattoos in a vaguely South Seas style to enhance the Haitian flavour.

MANTICORE

According to Ctesias, the Greek physician, the manticore was a beast roaming India that had three rows of teeth, the face of a man, the body of a lion and the tail of a scorpion. It could shoot quills from its tail like arrows.

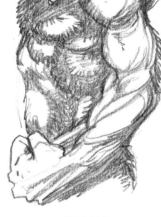

KAPPA

The kappa were Japanese water-demons that took the form of humans with bowl-shaped depressions on top of their heads. This held water, without which the kappa would lose its powers. They were said to have turtle shell bodies.

GARUDA

Garuda is the steed of the Hindu god Vishnu. Garuda is half-vulture and half-man, with a white face, red wings and a golden body. Images of Garuda can be found throughout India, but I chose instead to imagine my own version by referring to photographs of vultures. The one I used as reference had a particularly long and ruffled neck.

SATYR

Satyrs had the upper torso and head of a human and the lower parts of a goat. They were lascivious, drank wine and relished dancing. This is a particularly grotesque example of a satyr.

MINOTAUR

The minotaur was half-man, half-bull, and lived at the centre of a huge labyrinth on the island of Crete. I tried drawing the minotaur with a buffalo's head instead of a bull's head and I liked the way it looked.

ICHTHYOCENTAUR

The ichthyocentaur had the top half of a human and the bottom half of a dolphin. I tried this idea a few times but didn't find it very interesting, so I inverted it and came up with a creature with the head of a fish and the body of a man.

OVER TO YOU

■ *Read some descriptions of mythical beasts in books and try to imagine what they would be like rather than look at existing interpretations. Use tracings from picture books of animals to piece together the various body parts.*

■ *Don't stick rigidly to the original descriptions. Experiment and see what new possibilities occur as you go along.*

This immaculately crafted clay model shows how a well-designed hybrid can produce a striking and memorable character. 'Spider Queen', Patrick Keith

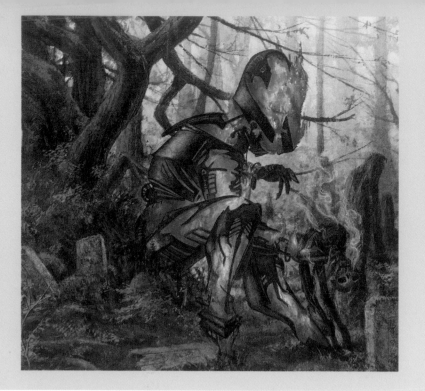

- *Study examples of animal armour, including fish and reptiles scales, the shells of crustaceans, the talons and beaks of birds of prey, and details such as quills, spikes and tendrils.*
- *Draw some basic body armour, then add some elements from your animal research.*

This incendiary beast is original and inspiring, and suggests an interesting approach to armour design.
'Incendiary Beast', Rob Alexander

ORNAMENTATION armour

THERE IS A TREMENDOUS AMOUNT OF RESEARCH MATERIAL AVAILABLE FOR ARMS AND ARMOUR, SO FINDING INSPIRATION IS NOT DIFFICULT. MEDIEVAL EUROPEAN DESIGNS FORM THE BASIC TEMPLATE FOR MOST FANTASY ARMOUR, BUT YOU CAN ADD INGENIOUS EMBELLISHMENTS BASED ON TRIBAL WEAPONRY, MODERN WARFARE MACHINERY AND FEATURES FROM THE ANIMAL KINGDOM.

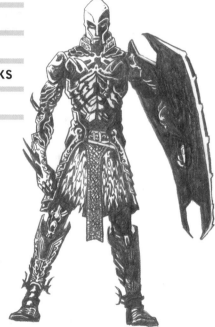

FRONT

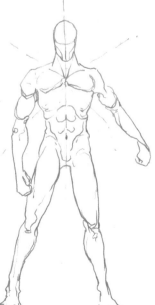

1 Start with the figure in the pose you want.

2 Using a lightbox and tracing paper, start to wrap armour around the figure. I have used a style inspired by shellfish, with numerous overlapping plates. It is common to have a kilt or chainmail skirt around the waist area. Notice that a lot of detail is put in at this stage that will eventually be lost when shading is added.

3 Add the shading. I have used a hard light from the right to emphasize the strength of the character, leaving most of the left side completely dark. You can work the shadow up to the edge of each plate of armour, but try leaving a white line along the leading edge of the plates where they would be thicker or have a raised edge. Finally, add a few touches of fine scrollwork to represent ornamentation on the armour itself.

PROFILE

 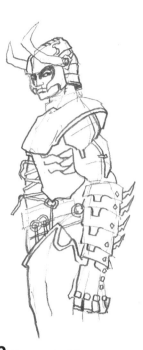 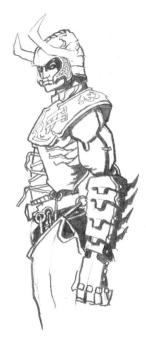 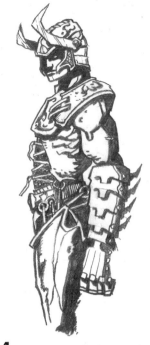

1 This image is looser, more like a shot from a comic strip or a visual for a film. Using a lightbox and tracing paper, add directional lines to give a feel for the flow of the armour as it fits around the body.

2 Start to build up the armour, allowing it to emphasize and exaggerate the muscles beneath. Add some buckles and ties (the pencil lines beneath them will be erased later).

3 Add ridges to some of the leading edges of the armour, such as the shoulder and thigh plates, to add weight. Begin to draw shadows on the lower edges to suggest the shadows beneath the armour and give the impression of overhang. Add some graphics on the plates. Note that the cheek shields have a random pattern on them. Such details do not have to be perfectly accurate.

4 Add heavier shadows and go over each line to strengthen it. This is a largely instinctive process and will develop with time. You have to learn to work the line in the way that you would sculpt a piece of clay, gradually finding the best shape. Add a line to the gauntlet to give it a more metallic effect, and include some small nicks and dents to increase realism.

HELMETS

ALEXANDER THE GREAT

This helmet seems to have been modelled on a leopard's head with added horns. Alexander was known as 'the two-horned', partly as a result of this headgear and of his reputation for behaving like a demon from hell.

SAMURAI

The domed top is fashioned from metal but the sides are a mixture of metal and fabric. The helmet is completed by thick bands of ropelike fabric that attach it around the chin and to the neck piece. It clearly offers great protection and is very attractive, but it seems cumbersome in comparison to the Islamic design.

ISLAMIC

The chainmail hood protects the neck and sides of the head while allowing unrestricted movement. The horns are a common feature in helmet design and recall the look of the classic Viking helmet. The fine detail of the moustachioed face shows a high degree of refinement and may seem whimsical considering what the wearer might be doing to you.

GREEK HOPLITE

This helmet was worn by Alexander the Great's troops and predates the other by several centuries. Consequently, there is far less ornamentation, save for the extravagant plume. The cut of the eyeholes and cheek guards presents a powerful warrior image.

ORNAMENTATION weapons

FROM THE AMERICAS TO THE FAR EAST, FROM AFRICA TO THE PACIFIC AND AUSTRALASIA, HUMANKIND HAS SHOWN THE MOST INCREDIBLE IMAGINATION WHEN IT COMES TO DEVISING INGENIOUS TOOLS FOR THE DESTRUCTION OF OTHERS.

PIKES

You can see by these examples from Switzerland that arms need not be symmetrical. The blades have elaborate curves and the shapes vary on each side of the staff. The staff is drawn with a wood grain and the lines are quite rough. You can add metal sheaths to the staff and ornamental tassels for a bright splash of colour.

SWORDS

1 The sword is essentially the hero's weapon. It symbolizes the power of good over evil. Swords with writing on them denote mystical origins and can usually be relied on to get a hero out of trouble. Many swords have names, such as King Arthur's Excalibur.

AXES

1 The blades of axes have a basic shape that you can cut into to make them more elaborate. This one was inspired by the shape of a scorpion.

2 The axe can be finished off with a sheath on the staff. The handgrips can be made of twine wrapped around animal skin or metal. The sheaths are more convincing if they are noticeably thicker than the staff they are wrapped around.

3 These throwing axes come from Africa and have an interesting variety of blades. They are beaten from a single piece of metal and do not have any sheaths or ornamentation.

2 On the right you can see how an asymmetrical hilt can work for a sword. You can get the impression of complex ornamentation without having to worry about being perfectly symmetrical. Swords of African and Asian origin often have curved blades.

HAMMERS

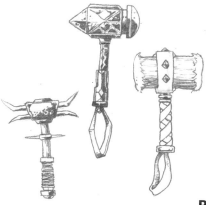

MACES

1 Maces have pretty much the same appeal factor as hammers, but their chains allow their wielders to swing the weapon with more flourish. Draw the shaft in the same way that you would draw a hammer or pike shaft. The mace head should be round with lots of wicked-looking spikes.

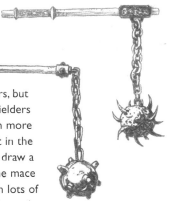

2 Chains, along with chain mail, can be difficult to draw, but they are common in fantasy art, so it's important to learn how. Draw the centre line first, showing the flow and direction in which you want the chain to hang. Add the two outer lines that run parallel to it. You can then roughly subdivide the lines to help guide the links. Add shadow to finish the chain.

Hammers are popular with orcs and other dark denizens of the underworld. Where the sword has a refined symbolism, the hammer appeals to the more basic instincts of the ogre type. The effect on the victim reflects these tastes – a hammer blow is not as clean a death as a sword stroke. Two of the hammers shown here have straps for swinging. You can experiment with different head types. I've shown a wooden head, a metal head and a spiked head for variation. The aim is to come up with a design that will cause the most mess.

BRASS KNUCKLES

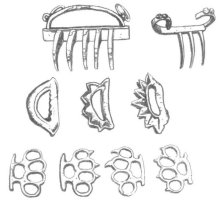

These examples of brass knuckles all come from Asia and show the many variations that are possible. Some are obviously inspired by tiger claws, while others are fashioned with blades. Adding brass knuckles to drawings of orcs, goblins and other wicked beasts enhances their aggressive appearance.

DAGGERS

These daggers from India give an idea of the elaborate ornamentation that has evolved on some arms. One dagger features a hand sculpted from brass and the hilt bears a leopard's head. Another has a carved elephant and tigers on the hilt.

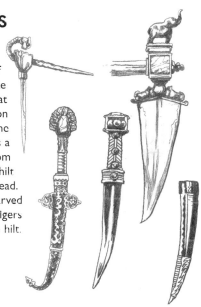

OVER TO YOU

■ *Referring back to your research into animal armour (see page 72), try using claws, beaks and talons as inspiration for creating different shapes of blades.*

■ *Practise adding lines of shadow and using an eraser to create metallic-looking highlights on the blades.*

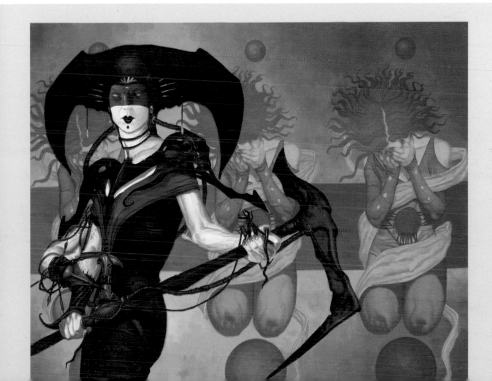

Wielding a strange array of weapons and armour, this unique character is made all the more menacing by her apparent elegance and beauty. 'Avatar of Woe', RK Post

ORNAMENTATION totems and masks

A TOTEM IS AN OBJECT OR MARK USED BY A TRIBE, CLAN OR GROUP TO DEFINE ITSELF. IN THIS SENSE, IT IS A KIND OF LOGO OR BRAND. MASKS HAVE AN OBVIOUS ROLE AS A PROTECTIVE DEVICE BUT THEY ARE ALSO USED FOR RITUALS. WHEN AN INDIVIDUAL PUTS ON A MASK, HE OR SHE TAKES ON A NEW IDENTITY — THAT OF THE MASK.

TOTEMS

The variety and diversity of totem designs from around the world provide a rich resource for fantasy character design. Apply them to your fantasy characters to build up a heavy veneer of interesting and imaginative detail.

FIGURINE TOTEM

Figurine totems vary from realistic representations to bizarre human/animal hybrids, giving you the chance to experiment with all kinds of weird and wonderful expressions.

ANIMAL TOTEMS

Animal-based carvings in stone or wood are used as a sort of good luck charm. They can be adorned with a variety of logos or bindings to add to their fetishistic appeal.

TOTEM POLE

In Native American cultures, totem poles are used both to define the tribe or clan and to tell its story. They are usually composed of a variety of animal and human figures.

OVER TO YOU

■ *If you can't get to an ethnographic museum, try searching on the Internet or looking in old books for reference material. National Geographic magazines will reveal some interesting possibilities if you are open minded about it.*

■ *Use the references you find to take the opportunity to break with convention. What would your hero look like with facial tattoos or an enormous hairpiece?*

This highly stylized emblem uses the motif of a spider to give it a dark appeal.
'Spider Icon', Anthony S Waters

A mask can have a number of meanings and uses. In this case, it enhances the composition and emphasizes the expression and demeanour of the figure.
'Strangeworld I', Martina Pilcerova

SKULL TOTEM

A gruesome collection of skulls, horns and bones makes the perfect totem for an orc or troll. Making your creations interesting can often mean trying to find the unexpected – you could try drawing a totem of shrunken heads, for example.

MASKS

JAPANESE THEATRE MASKS

The Japanese have a long tradition of creating the most elaborate and exquisite masks for use in theatre. These examples can provide inspiration for a wide range of extreme facial characteristics and expressions that translate well into character drawing.

AFRICAN MASKS

African masks show a tremendous diversity of styles and can provide inspiration for characters and creatures as well as expressions. Try not to imagine them as masks, and instead transpose them onto flesh, blood or even metal. Make them into robots or machines, giants or pygmies. Look closely at the different techniques used for showing a frown or an eyelid or a mouth, and apply these in places where they would be least expected.

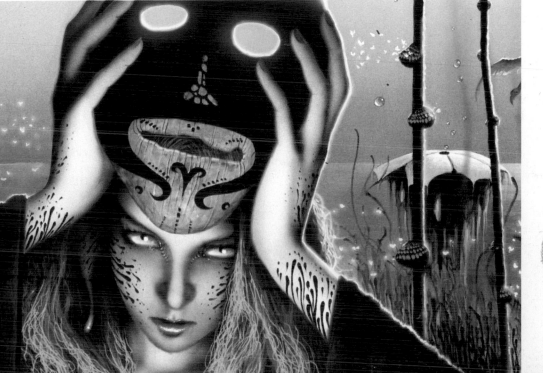

ORNAMENTATION patterns

MANY FANTASY ARTISTS USE PATTERNS TO CREATE ELABORATE BORDERS FOR THEIR ARTWORK AND ON CLOTHES, ARMOUR AND SET DESIGN. THE BASIC PRINCIPLE IS SUBDIVISION AND REPETITION, WITH THE MOST COMPLEX FORMS ARISING FROM A BASIC UNIT, SUCH AS A CIRCLE OR TRIANGLE. THE CELTIC AND ISLAMIC PATTERNS SHOWN HERE APPEAR SIMPLE BUT CAN BE DIFFICULT TO REPLICATE AT FIRST.

CELTIC BANDS

1 Begin with a series of parallel dots. Add diagonal lines to join them. Then add arches above and below.

2 Create breaks in the pattern, as indicated by the arrows and rejoin the lines accordingly. This is a critical point because the pattern will be affected by where you create the breaks, which you can do in a variety of ways.

3 Add an outer line and an inner line to give the pattern its shape.

4 Erase the guidelines to leave the basic pattern and experiment with ways of making the strands overlap each other. This is another critical point because you must learn how to make the pattern repeat itself by making the overlaps consistent.

5 This illustration shows some variations from the same initial pattern. You can see how the strands can be tightly knotted without the spaces in between. You can also add inner lines and take away the central line. It may seem confusing and frustrating at first, but persevere and it will eventually start to make sense.

CELTIC SPIRALS

1 Draw a series of dots equally spaced across a circle, then draw lines joining the dots as shown. The example above right shows a two-coil spiral and the one below right a three-coil spiral.

2 Again, there are endless variations you can explore, such as the arrangement of seven interconnecting spirals shown here.

A dragon, a Celtic knot and a surface of polished stone – a wonderful combination for a unique fantasy creature. *'Dragon on Dinosaur Bone'*, *Carl Buziak*

ISLAMIC TRIANGLES

1 Draw a circle with a compass. Keeping the compass at the same radius, place the point on the circumference and use it to mark off points along the circumference. This will cut the circle into six equal parts and create a floral pattern. Join the points to make a hexagon.

3 You can then carry on indefinitely, creating more triangles within the shape of the hexagon.

2 Join the points across the circle to make two triangles that look like a star. This is where subdivision really starts to work. If you draw lines where the two triangles intersect each other, you end up with another set of equally spaced points around the circumference of the circle.

4 Use the grid to create a variety of interlocking and overlapping shapes. A simple triangle example is shown here.

ISLAMIC STARS

This illustration shows a variation of the same method, starting with a compass and using its radius to mark points on the circle. You can see that once you have created the first hexagon, it's quite simple to draw the ones next to it by following the lines through. It's easy to see the progression through 1, 2, 3 and 4.

OVER TO YOU

■ *Trace the examples on these pages. This will give you important insights into how the process works and this essential understanding will save you frustration in the initial stages.*

■ *Then start to construct your own pattern. Don't try to skip any stages or it will end in disaster. Once you get going, you'll be amazed at the things you begin to learn about how shapes and patterns work.*

Once an understanding of pattern has been mastered, the artist can evolve infinite and increasingly abstract variants. 'Past Reflections', Carl Buziak

FANTASY WORLDS basic perspective

PERSPECTIVE DRAWING IS ONE OF THE FUNDAMENTAL SKILLS FOR ANY ARTIST, ALLOWING YOU TO DRAW OBJECTS THAT APPEAR TO FORESHORTEN INTO THE DISTANCE. IT IS ESSENTIAL FOR DRAWING ANYTHING AND EVERYTHING — BUILDINGS, LANDSCAPES, INTERIORS AND EVEN FIGURES.

ONE-POINT PERSPECTIVE

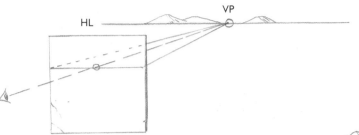

1 Start by drawing the horizon line (HL). This is the line of the landscape farthest from the artist. It is also known as the eye level because it is always at the eye level of the artist. The horizon line is usually drawn parallel to the top and bottom of your paper. Now add a vanishing point (VP) on the horizon line. This is where all the receding lines of the picture appear to converge.

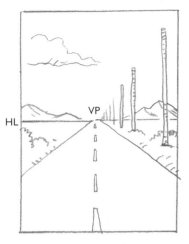

2 You can see here how the lines of a highway all meet at the vanishing point. Also, if you were to draw a line along the top and bottom of the poles to the right of the highway, these, too, would appear to converge at the same vanishing point.

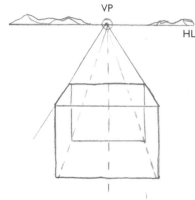

3 Use the horizon line and the vanishing point to construct an object that appears to foreshorten. Draw some lines fanning out from the vanishing point to construct the outline of a cube. Note that the lines that form the front and back of the cube are strictly parallel or at right angles to the horizon line. For this cube, the lines have been drawn downward from the vanishing point so that we appear to be looking down on the cube.

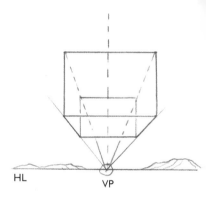

4 If we draw the lines above the horizon line, the cube appears to be above us. We have the impression that we are looking up at anything drawn above the horizon line.

TWO-POINT PERSPECTIVE

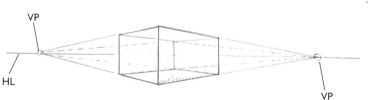

1 Use two-point perspective for objects that appear to be at an angle to the viewer. Draw the horizon line and add two vanishing points anywhere along the horizon line. It's best to keep them well spaced to begin with. Draw lines outward from the vanishing points and then add vertical lines to construct an object. Notice that the vertical lines are all parallel to each other. In this example, the object appears to be both above and below the horizon line, which means that you are looking up at the top half of the object and down at the bottom half.

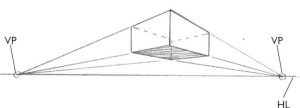

2 As with one-point perspective, we have the impression of looking up at anything drawn above the horizon line. This is useful when drawing flying objects, such as aircraft.

3 Likewise, when we draw all the construction lines below the horizon line, we have the impression of looking down on the object. This is useful when drawing furniture and aerial views of cityscapes.

INTERIOR

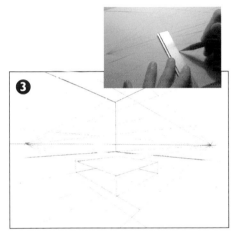

1 Try using two-point perspective to construct an interior. First, draw the horizon line and two vanishing points. Then draw a series of lines fanning out from these points, above and below the horizon line. Always draw your lines starting from the vanishing point. Put your pencil on the vanishing point, then slide the ruler up to it. Draw the line, then put your pencil back onto the vanishing point before moving your ruler up or down to the position for the next line.

2 Now add some vertical lines. I have added just one here to form the far corner of the room. Next, take your ruler and line up the top point of the vertical line with either of the vanishing points. By drawing outward from the top of your vertical line, you can create the top horizontal lines of the walls of the room. Do the same at the bottom of the vertical line.

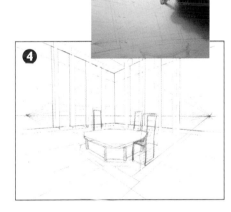

3 Use the same process to create the basic shape for a table in the centre of the room. Begin with a single vertical line, wherever you like, and draw some lines towards the vanishing points from the top and bottom of this line. These lines drawn to the vanishing points form the top and bottom of the table, so you must then choose where the other vertical lines will go. Their size will be dictated by the perspective lines you have just drawn from the first vertical line.

4 Use the same basic process to add pillars and other furniture. The chairs are based on the basic cube shape, and their lines match up with either of the vanishing points. For variation, you can cut into the basic cube shape to make the table a hexagon. This can be quite difficult to begin with, so you will need to practise.

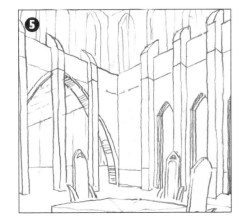

5 Finally, add more detail, such as arches and a gallery at the top of the wall. Make sure your vertical lines are all parallel because otherwise your picture will start to look askew. Be warned. This can be incredibly frustrating to begin with, but it is essential that you learn this skill. No artist can get by without it.

FIGURE

It may seem crazy, but you can use perspective lines to draw figures as well. Draw a basic grid and use it as a rough guide to drawing a figure. The lines of the figure don't have to match up perfectly with the vanishing points, but following the grid fairly closely will help to give your figure a more dynamic pose. This method is particularly useful when drawing a figure that you are looking down on or up at.

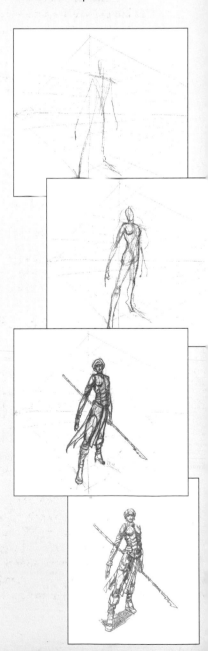

FANTASY WORLDS advanced perspective

AS THE NAME IMPLIES, THREE-POINT PERSPECTIVE ADDS A THIRD VANISHING POINT (VP). THIS ENHANCES THE IMPRESSION THAT WE ARE LOOKING UP OR DOWN AT AN OBJECT. THE THIRD POINT IS NOT PLACED ON THE HORIZON LINE (HL) LIKE THE OTHER TWO, BUT ABOVE OR BELOW IT INSTEAD.

Three-point perspective often requires that the first two points be widely spaced. You might find that, in order to get the angle you are looking for, your perspective points are off the page. This may be hard to deal with at first, requiring you to draw the points on your drawing board and use a very long ruler, but eventually you will be able to judge perspective without using a ruler at all. In fact, once you have mastered the rules of perspective, you will be able to break them by twisting perspective and changing it to create different visual impressions, as some of the examples here demonstrate.

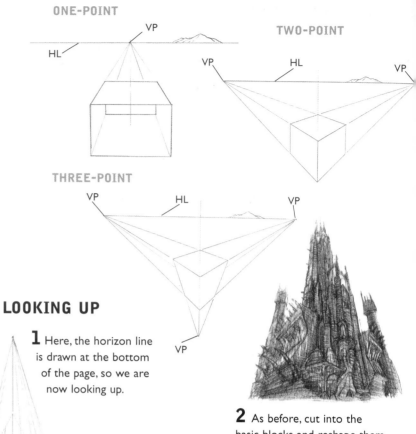

ONE-POINT

TWO-POINT

THREE-POINT

LOOKING UP

1 Here, the horizon line is drawn at the bottom of the page, so we are now looking up.

2 As before, cut into the basic blocks and reshape them with the confidence that you have strong perspective lines to work to. In this case, the blocks have been rounded into circular towers.

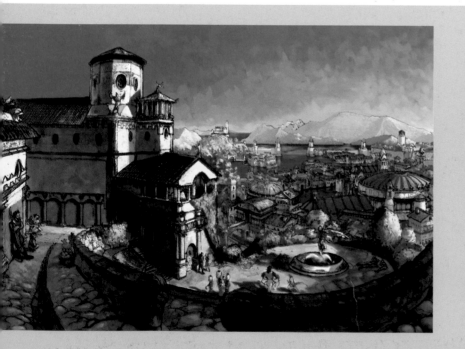

OVER TO YOU

■ Copy the one-, two- and three-point perspective examples shown here. If this fails, trace them until you figure them out. Always remember to draw your lines by placing the pencil tip on the vanishing point and drawing outward every time.

■ After you've mastered the cube, add other cubes and build them up into different shapes, such as buildings. Experiment with cutting into the shapes to make objects such as chairs. Finally, draw a complete interior or architectural scene.

The background of this panorama adheres to a fairly stable perspective, but the foreground pathway is convoluted into a fish-eye view. 'Tazoun', Anthony S Waters

LOOKING DOWN

1 Position the horizon line above the objects so that we seem to be looking down on them.

2 Chip away at the basic blocks to create more natural forms, such as the decaying temple perched on a batholith shown here.

This painting was produced as a foldout for a Led Zeppelin CD booklet. It is a good example of how different types of perspective can be represented in a single image. The illustration was structured using the principles of Islamic geometrics (see page 79). Six squares were drawn and then subdivided into smaller and smaller units to produce everything else.
'Drop City', Finlay Cowan & Nick Stone

BREAKING THE RULES

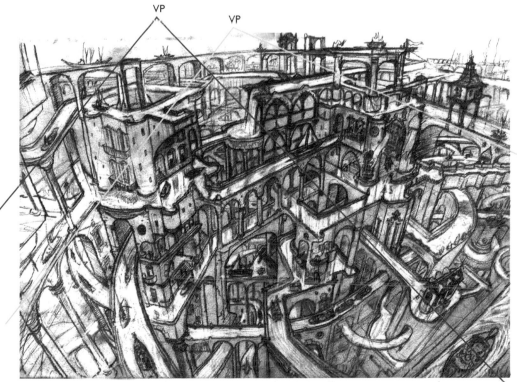

As your confidence with perspective builds, you will find that you can draw perspective without using guidelines. This example was drawn freehand. You can see from the two examples of perspective lines I've added that the perspective is not entirely accurate. This was partly deliberate, in an attempt to create a wide-angle or fish-eye lens feeling to the drawing. *'City of Black Water', Finlay Cowan*

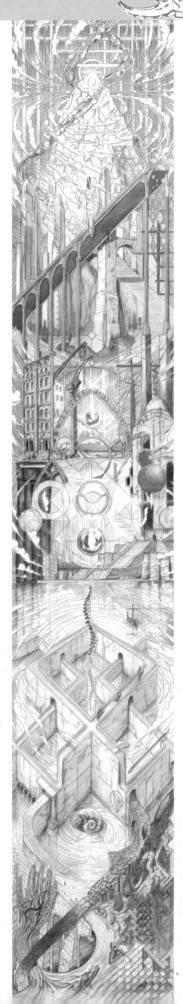

FANTASY WORLDS castles

A FANTASY WORLD JUST ISN'T COMPLETE
WITHOUT A CASTLE OR SOME OTHER FORM
OF TOWERING EDIFICE. A GRASP OF THE
FUNDAMENTALS OF PERSPECTIVE DRAWING
WILL ALLOW YOU TO CREATE ANY STRUCTURE
YOUR IMAGINATION CAN CONJURE.

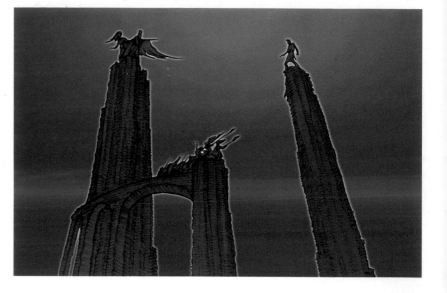

This image was drawn using three-point perspective to enhance the sense of the figures balancing precariously on the lofty towers.

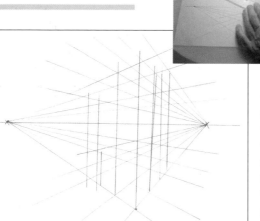

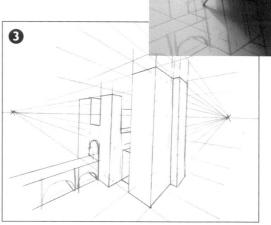

1 Draw the horizon line and then add perspective lines, always drawing outward from the vanishing points. I've used two-point perspective here and drawn a lot of lines that aren't strictly necessary, but they form a grid that can guide you later on when you are adding detail.

2 Add the vertical lines and clean up the boxes with an eraser.

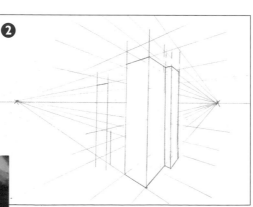

3 Add the main details, such as arches. Do this by drawing a centre line and then creating the curve of the arch. Erase the extra lines.

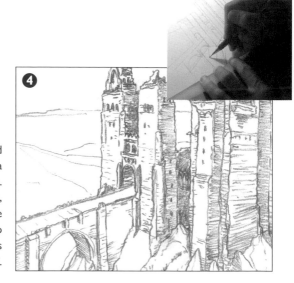

4 Add organic details, such as the slopes and hills surrounding the castle. This provides a sound structure for creating the final drawing. Details such as the texture of the walls, battlements and variations in the architecture can be added much more easily now. Simply chip away at the stonework and round off corners or create domes within the original blocks.

OVER TO YOU

■ *Follow the exercise shown here, but only as far as defining the basic blocks of your building.*

■ *Now let your imagination roam around the shapes. Experiment with new ways of breaking the shapes up into smaller units and adding interesting architectural features.*

Large floating rocks can be seen in the surrealist art of René Magritte. In this painting, they have been developed into curious and inviting castles. 'The Guardians', Christophe Vacher

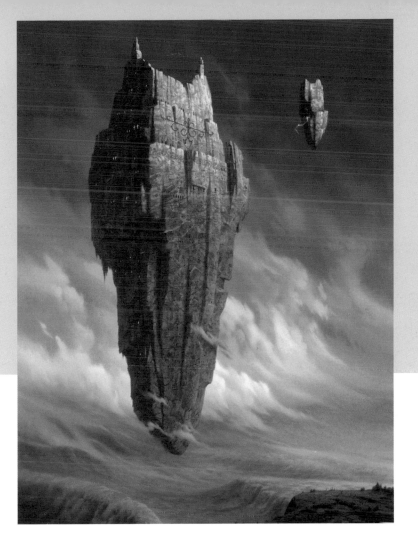

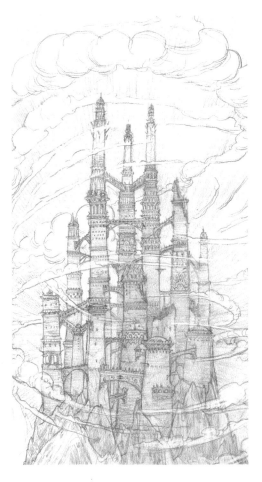

The directive for this drawing was to create a kind of cosmic time machine and to evoke an almost infinite sense of scale. It was drawn using two-point perspective to enhance the impression of the towers. The final artwork was photocopied and flipped to create this sense of a fantastic mechanistic landscape mirrored above and below. 'Five Peaks', Finlay Cowan & Nick Stone

This castle was drawn using one-point perspective, so it is seen straight on. Apart from the clouds, there is very little sense of foreshortening.
'Vykram's Castle in the Hindu Kush', Finlay Cowan

FANTASY WORLDS scale

IN THE WORLD OF FANTASY, YOU CAN NEVER DRAW A LANDSCAPE TOO BIG OR A BUILDING TOO MAGNIFICENT. THIS DRAWING SHOWS WHERE YOU MIGHT BEGIN AND END UP WHEN YOU START TO THINK BIG.

1 Draw a horizon line about halfway up the page, with the vanishing point just right of the centre. Draw in the grid of perspective lines.

2 Sketch the rough shapes of the landscape. The larger ones in front overlap those behind as they get smaller towards the horizon.

3 Most of the peaks cut through the horizon line, but you can still see it in the background. Seeing all the way to the horizon will give you more distance to play with.

4 Draw a hilltop castle perched on a lofty precipice and towering over the foreground peak. The castle was created by drawing a few cylindrical shapes that widen towards their base.

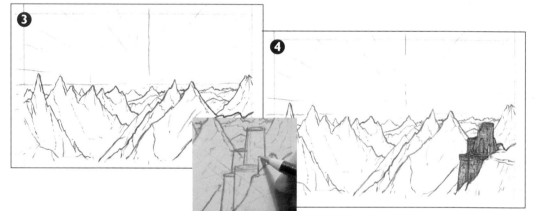

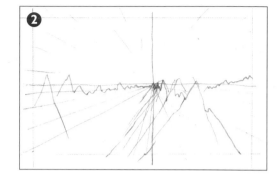

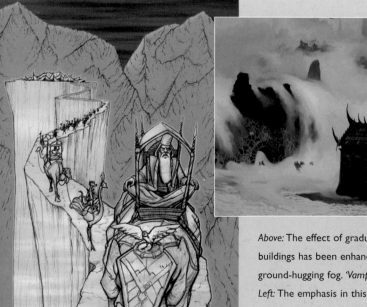

Above: The effect of gradually foreshortening the buildings has been enhanced by shrouding them in ground-hugging fog. *'Vampire Capital', Anthony S Waters*
Left: The emphasis in this image is on creating a sense of height rather than depth. *'Volkhar Escapes', Finlay Cowan*

OVER TO YOU

■ *Choose a classic painting or photograph that has a particularly strong effect on you. Try to reinterpret the image, putting a completely new slant on it.*
■ *You can change the perspective or viewpoint, add or remove elements, or exaggerate other aspects such as scale or colour. Your chosen image need not be fantastic to begin with, but it will be by the time you've finished with it.*

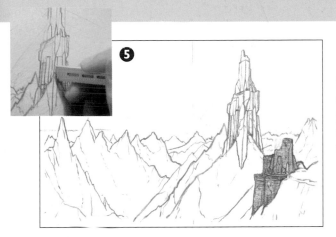

5 Normally, a building drawn in the distance would be smaller than one in the foreground. By making it larger, you emphasize its scale. The larger castle is made up of rectangular shapes with irregular attachments. Remove the original pencil lines of the mountain with a fine eraser.

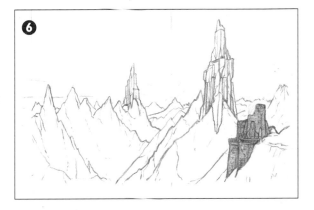

6 Siting a similar castle farther away gives a strong sense of the overall scale of the landscape. Compare this drawing with the previous stage, where the eye stays fixed on the foreground buildings. By placing something in the middle distance, we now have a sense of the space in between.

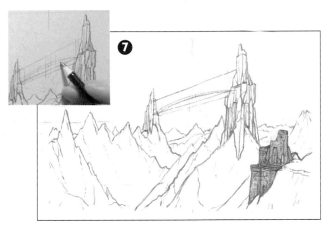

7 But why stop there? Here, the two buildings are joined together with an unfeasibly large bridge. We find ourselves looking up at the bridge because it is above the horizon line, so it appears to loom above us. Drawing curves in perspective is tricky. I find it easier to draw a rectangle, then draw the curves through it.

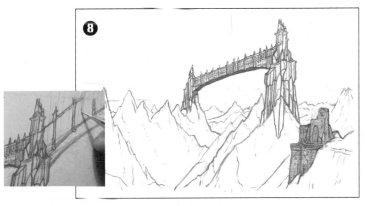

8 Add detail to the bridge to emphasize its scale. This can be frustrating because, in order to make the bridge look huge, the detail must be microscopic. The trick is to subdivide the object, then subdivide again and again. Alternatively, you can do a lot with colour and shadow later on.

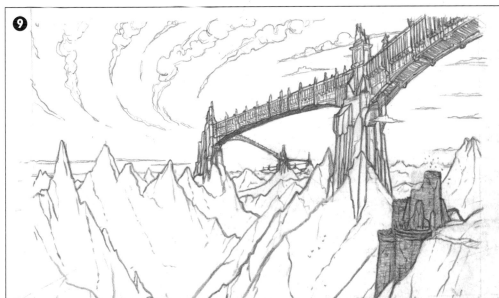

9 Add more towers and bridges, disappearing into the distance. Dynamic clouds roughly follow the lines of perspective, and some thin, flat clouds above the horizon punch out the peaks of the mountains that cross the horizon line. Two final touches vividly emphasize the enormous scale of the scene: a small cloud floating in front of the first tower and a flock of tiny birds above the foreground castle.

FANTASY WORLDS architecture

THE WONDERFUL THING ABOUT DESIGNING FANTASY WORLDS
IS THAT YOU ARE FREE FROM THE CONSTRAINTS OF REALITY,
ALLOWING YOU TO CREATE IMPOSSIBLE STRUCTURES — CASTLES
THE SIZE OF MOUNTAINS AND BUILDINGS THAT FLOAT IN THE AIR.
TO MAKE THE IMAGE CONVINCING, HOWEVER, ARTISTS USUALLY
REFER TO FAMILIAR ARCHITECTURE AND THEN EMBELLISH IT.

ISLAMIC ARCHITECTURE

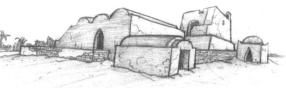

This is a drawing of a small rural mosque on
the island of Djerba in Tunisia. Djerba was the
legendary Isle of the Lotus Eaters in Homer's
Odyssey, a place that visitors would never want
to leave. Tunisia is well known for having
hosted the *Star Wars* films and its style of
architecture has clearly influenced the style
of buildings created for certain locations in
the film, such as the space port at Mos Eisley.

CLASSICAL ARCHITECTURE

The beauty of classical Greek and Roman
architecture is in its sense of rhythm and proportion.
It is based on an exact system of measurements that has
influenced building from ancient times right up to the present
day. These styles have their own particular set of components,
as seen in this example, and you can develop a valuable sense
of proportioning from studying and drawing classical architecture.

GARGOYLES

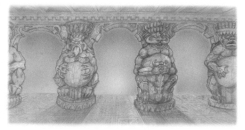

1 This colonnade of grotesque statues
was inspired by Indian and Asian styles
of architecture. The wide, solid bodies of
gargoyles are a common sight in temple
carvings in the Far East, although the extreme
look of these figures is an exaggeration.

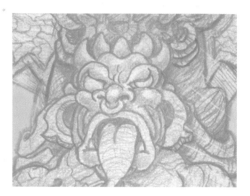

2 Detail can be effective in this kind of
drawing and should be built up gradually,
starting with the basic shapes and adding
detail in successive sweeps afterwards. This
is where your research and reference will
have the most influence. Looking at different
styles of architecture will help you define the
particular shapes and forms of architectural
ornaments that vary from culture to culture.

GOTHIC INTERIOR

1 This preparatory study
was inspired by the interior
of a gothic cathedral,
complete with the
characteristic arches and
vaulted ceiling. Gothic
architecture is the
style most
frequently
used by
fantasy
artists.

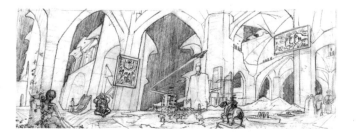

2 The final visual, which was designed as an intergalactic
museum for a documentary title sequence, took full advantage
of the opportunity to twist and bend the look of the gothic
cathedral into a suitably fantastic style of architecture. The
arches and vaulted ceiling remain, but huge holes have been
punched through the walls to reveal the space-age roofs of
the rest of the building. The cavernous interior has been filled
with an eclectic mix of objects.

SPIRAL CITY

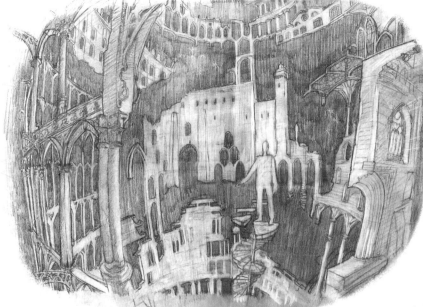

3 Specific architectural details from reality, such as this gothic arch, were grafted onto the fantasy concept. The use of such architectural details helps to make this fantastical world believable.

1 This series of visuals shows how a familiar style of architecture can be transposed onto a fantasy design concept. The original idea was to create a building suspended in space that coiled through eternity in an endless spiral. This concept led to the idea of a city hung on an apple-peel shape, shown in this initial rough.

2 The environment was developed as a continuous strip of architecture that evolved through a series of different styles. The dynamic of the drawing was enhanced by its execution in a fish-eye or wide-angle view.

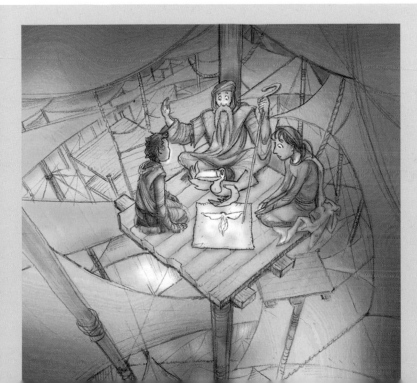

OVER TO YOU

■ *Study architectural reference material and practise drawing features such as columns, arches and other decorative details.*

■ *As you can see from the examples shown here, the concept for the image often comes first and an architectural style is then moulded to fit the idea. Try drawing your own intergalactic museum using different styles of architecture, such as Islamic or Asian.*

This illustration shows a magician's hideout tucked away in the upper reaches of a vast tent. Inspired by the rigging on a sailing ship, numerous overlapping sails were drawn to create a city of tents and an environment dominated by curves and vertical posts.
'Tent City', Finlay Cowan

set design

THIS CASE STUDY EXAMINES HOW ARCHITECTURAL
DRAWING TECHNIQUES ARE USED IN SET DESIGN
FOR FILMS AND COMPUTER-GENERATED
ANIMATION. THE EXAMPLE SHOWN HERE IS
RELATIVELY COMPLEX, BUT THE BASIC METHOD IS
POSSIBLY EASIER THAN DRAWING IN PERSPECTIVE.
The set designer begins with a 'plan' drawing. A plan is
a view of the ground floor as seen from directly above;
it shows the layout of the walls and other significant
details. After completing the floor plan, the designer then
produces an 'axonometric' drawing. This is an interesting
method of creating a scale drawing of a building that
appears to have a three-dimensional quality but does not
involve any perspective. There is no foreshortening, and
the method for producing an axonometric projection
is quite simple. It is used by designers because it allows
the set builders to take accurate measurements from
anywhere on the drawing when they are building the set.

3 The
designer then
produced an
axonometric drawing
by turning the plan roughly
45 degrees and tracing it on a
lightbox. The original drawing
was then shifted directly downward
and the plan retraced. This provides a
drawing of the walls at floor level and
another set at ceiling level on the same piece
of paper. It is important that the ceiling plan be
traced directly above the floor plan so that all the uprights are
vertical (that is, at a 90-degree angle to the bottom of the page on
which you are tracing the plan and parallel with the sides). All the
columns and walls can then be joined floor to ceiling using vertical
lines, all of which are parallel.
The lines of the columns and
the ceiling plan are shown
here in blue as an example.

1 This architect's plan
drawing by Paul Duncan
shows a view of the 'stage'
area from directly above.
In this case, the set was to
be built in a warehouse
location and the designer
had to work around a grid of
14 concrete columns, shown
by the square box shapes.
Doors and windows are
indicated by gaps in the walls.

2 The designer then
added all the walls to
the architect's plan. The
set in question was
going to be a bar with
a labyrinthine feel,
involving lots of hidden
corners and cubicles.
The designer arranged
all the features in a
rough spiral pattern. A
kitchen and lavatories
were included to make
the set convincing.

4 The next
stage is to add
doorways, windows,
seating arrangements
and other features such as
archways. The end result allows the set builders
to take a scale measurement from anywhere on
the drawing and replicate it in real life. It is worth
assessing the plan at this stage because angling the
original plan at a strict 45-degree angle when you
trace it can sometimes cause confusion in the
drawing if too many of the lines become hidden
or interfere with each other. You could retrace
it at a slightly different angle if necessary.

6 Other axonometric projections can also be produced from different angles and at varying sizes to refine and develop various details of the set.

5 The drawing can also be coloured to give an idea of the lighting and wiring schematic required.

7 After the plans and axonometrics have been approved, perspective drawings or visuals can be produced. Photographs were taken of the warehouse location using a wide-angle lens and then traced.

8 Using the axonometric drawing as a strict guide, the designer can accurately visualize all the interior features of the set and add colour and lighting embellishments.

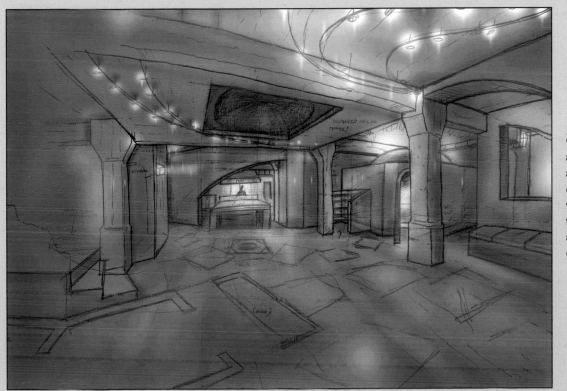

painting,inking and

digital art

MANY DIFFERENT MEDIA CAN

BE USED TO DEVELOP YOUR

PENCIL SKETCHES INTO FINISHED

DRAWINGS, INCLUDING INK, MARKER PENS, WATERCOLOURS,

OILS AND ACRYLICS. THE WORLD OF DIGITAL ART IS ALSO EXPLORED HERE,

FROM HOW TO COLOUR, ADJUST AND COMPOSITE YOUR DRAWINGS TO CREATING

DIGITAL ARTWORK FROM SCRATCH. EACH OF THE TOPICS DISCUSSED IN THIS

CHAPTER WOULD REQUIRE SEVERAL BOOKS TO COVER THEM FULLY, SO I HAVE

CONCENTRATED ON PROVIDING AN OVERVIEW THAT WILL HELP YOU DECIDE

WHICH AREAS YOU WOULD LIKE TO PURSUE FURTHER.

PAINTING AND INKING equipment

ALTHOUGH RECENT ADVANCES IN COMPUTER TECHNOLOGY HAVE MADE IT POSSIBLE TO REPRODUCE A VARIETY OF TRADITIONAL PAINTING AND INKING TECHNIQUES DIGITALLY, MOST FANTASY ARTISTS ARE ALSO PROFICIENT IN THE OLD-FASHIONED METHODS.

The equipment for inking is relatively specific, whereas the choice of painting materials is enormous. The artist will find a veritable cornucopia of art materials in most art supply stores and the choice can be baffling. Rather than getting carried away and buying everything at once, start by choosing a medium that appeals to you and buy just a small selection of materials with which to experiment. You can then decide if you want to invest in more of them. For instance, start with a few small tubes of oils and a couple of inexpensive brushes before investing in a wide range of colours and top-quality brushes.

BLACK INK
Many different brands of black ink or Indian ink are available. Always choose the waterproof or permanent variety.

INKING

FOUNTAIN PENS
Fountain pens are useful because they are cartridge fed and do not require dipping. 'Calligraphic' pens and 'manuscript' pens are available with varying sizes of flat nibs that can give a variety of line widths in a single stroke.

WHITE PAINT MARKERS
White paint markers such as the one shown here are used for adding highlights to marker drawings.

QUILL PENS
Quill pens are the old-fashioned-looking pens that need to be dipped in a pot of ink. They are the type most commonly used by comic book inkers. The technique can be difficult to learn but, once you have mastered it, this type of pen is very reliable. The Hunt 102 is the industry standard. Begin with this, together with the 107 and 512 for flatter and bolder lines.

TECHNICAL PENS
Technical pens come in a variety of nib sizes and give a consistent line without any variation. There are numerous manufacturers, and you can begin with three nib sizes such as .01, .05 and .09. Many artists also use technical pens in different colours, such as browns, and then paint over them or blend them into paint work.

INKING BRUSHES
The choice of brushes is endless. The springiness of sable brushes makes them ideal for line work and, although expensive, they will be worth the price you pay in the long term. Many artists recommend the Winsor & Newton series 7 brushes, using numbers 2, 3 and 4.

PAINTING

OILS

Oils are the industry standard for illustrators and fantasy painters. They have the best colour depth and take longer to dry than other media, allowing the artist more time to push the colours around and mix them on the canvas.

BRUSHES

There is an enormous variety of brushes to choose from. Begin with budget brushes while you practise and find out which widths and lengths you prefer, then invest in quality brushes, which last longer and give a better line.

WHITE PAINT

You will need non-bleed white paint that can cover black ink. Normal white-out products such as Liquid Paper do not work on Indian ink.

ARTISTS' MEDIUMS AND VARNISHES

Blending and painting mediums are mixed with paint to improve the paint's flow and extend its drying time. They are used for increasing the transparency of paints for blending and overpainting techniques.

WATERCOLOURS

Watercolours are considered to be one of the hardest mediums to use because they dry so quickly and flood all over the paper, but it really depends on what you are trying to achieve. They are excellent for quick sketches and creating interesting bleed effects.

STUDIO MARKERS

Felt marker pens are used in conjunction with technical pens. They are the industry standard in the advertising and film worlds, and artists aiming to work in these fields should show marker work in their portfolios. Markers come in a wide variety of colours and they are expensive. They can be used only on bleedproof marker paper, which is also expensive. Furthermore, they are difficult to use and do not respond to the hand as fluidly as a pencil or brush. So why use them? The reason is that they are by far the most effective way of getting visuals down fast and, with a little practice you can produce dynamic and striking visuals far more quickly than you could with any other medium. Fortunately, they are refillable. You can begin with three or four. Choose a selection of dark, medium and light grey, or another neutral colour such as blue.

ACRYLICS AND GOUACHE

Acrylics and gouache are cheaper than oils and dry more quickly. Consequently, they are a good medium for practising with while you develop your skills and confidence.

COLOURED INKS

Coloured inks are used to achieve large areas of flat colour and to create subtle blends. Many artists use them together with other media, such as paints or pencils, to create a variety of effects. Their advantage is that their colours are strong and consistent. However, flat colour work is now best achieved digitally using Photoshop, Painter, Illustrator or Flash.

OTHER MEDIA

Other media, such as pastels, coloured pencils, aquarelles, Conté pencils and charcoal, are all used in a variety of ways by different fantasy artists to achieve different effects. Experiment with different media as your skills develop, and see which you enjoy working with the most.

PAINTING AND INKING applying ink

INK CAN BE APPLIED WITH EITHER A PEN OR BRUSH. THE BRUSH IS PERHAPS THE MOST RESPONSIVE ART TOOL EVER INVENTED. IT'S ALSO THE OLDEST, UNLESS YOU INCLUDE FINGER PAINTING, WHICH SEEMS TO HAVE LOST POPULARITY SINCE ITS HEYDAY IN PREHISTORIC TIMES.

The brush probably remains popular because of the variety of marks that can be made in a single stroke, which allows the artist to work quickly and expressively. The brush can take time to master, and the beginner will find it hard to draw the same line twice, which causes problems with developing a consistent style.

Becoming adept at using a brush is only a matter of practice. In the interim, you can experiment with using ink pens. They are less expressive than a brush, but expressive nonetheless, and their appeal lies in the consistency of line that they give.

PEN WORK

Ink pen work is commonly used to create areas of tone in black and white images. Areas of crosshatching can be built up from layers of lines running in different directions to create gradients. Line work is also used for creating a variety of textures and tactile surfaces, from skin to stone.

TONE

CROSSHATCHING

TEXTURE

BRUSHWORK

It takes time to learn how to maintain consistent brush strokes because the amazing variety of lines a brush can produce with a single stroke makes it hard to produce the same line twice. The effort it takes is worthwhile, however, because of the freedom of expression a brush eventually provides.

INKING STYLES

This series of images shows how the same pencil drawing is affected by the use of different inking mediums.

TECHNICAL PEN

A technical pen produces a clean, consistent line and will allow you to develop a distinctive style fairly quickly. It is easy to build up areas of tone but the result lacks the expressive line quality that can be achieved with ink pens and brushes.

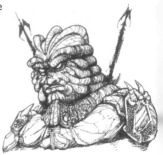

FOUNTAIN OR QUILL PEN

A fountain or quill pen gives a greater variety of lines but still allows a certain amount of consistency. As such, it falls halfway between the technical pen and the brush.

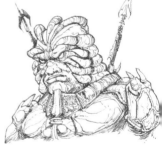

BRUSH

It takes longer to develop a distinctive style with the brush but it is ultimately the most flexible tool of all.

A brush makes it easier to reproduce the tone and depth of the original pencils and encourages the use of deep, striking shadows. The brush is also the quickest tool to use because it allows the greatest variety of different effects without having to change equipment.

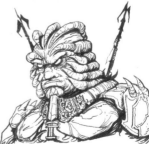

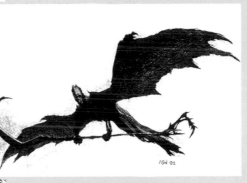

A variety of ink effects have been used in these two drawings, including working with white to pick out details in the black ink in order to create interesting lighting effects. 'Necromancer's Moon' (left) & 'Death Angel' (above), Anthony S Waters

OVER TO YOU

■ Sculpture collections are good for learning to draw shadow because the individual statues are generally very well lit. Visit a museum or gallery to make a series of shadow studies.

■ Start by using a pen, then progress to brushwork. Developing a good appreciation and observation of the way light and shadow work on any surface can have a profound effect on your painting skills.

SHADOW

This series shows how different lighting sources will affect the same image and how, to some extent, lighting, and the shadow it causes, will affect the mood of an image. To emphasize the direction of the light source, these examples are all shown with hard lighting and very little use of tone.

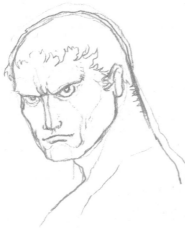

SIDE LIT FROM LEFT
The right-hand side is drenched in heavy shadow.

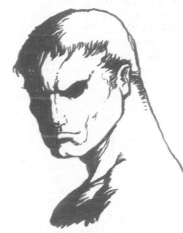

SIDE LIT FROM RIGHT
Both eyes are completely blacked out.

LIT FROM BEHIND
Well, sort of. Notice how putting a tiny highlight in the pupil of the eye can enhance the character.

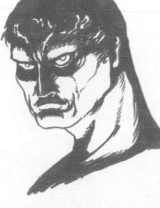

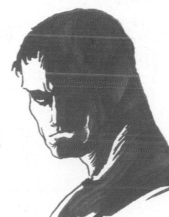

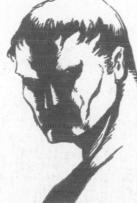

LIT FROM BELOW
All upward-facing areas must be in shadow.

LIT FROM ABOVE
The light throws long shadows down from any downward-facing planes.

PAINTING AND INKING marker figure

MARKER VISUALS ARE USED WIDELY THROUGHOUT THE FILM AND ADVERTISING INDUSTRIES AND ARE AN ESSENTIAL ELEMENT IN ANY FILM DESIGNER'S SKILL BASE. MARKERS ARE USED FOR PRODUCING IDEAS FOR CHARACTERS, COSTUMES AND SETS AT GREAT SPEED, AND THE BASIC METHOD ALLOWS FOR SEVERAL VARIATIONS OF AN IDEA TO BE PRODUCED QUICKLY.

The original drawing is usually a pencil sketch, which is placed on a lightbox and traced with markers on bleedproof marker paper. Marker work is often produced entirely in greys or neutral colours. For a wider colour range, the original can be modified in Photoshop or retraced with different colour schemes. The artist begins with the lighter tones, then adds shadow afterwards. Black lines are drawn with a technical pen at the end. In the example shown here, the black lines were drawn on a separate sheet of paper and added as an overlay in Photoshop. This isn't necessary but it does allow the marker colours to be adjusted separately from the black ink line.

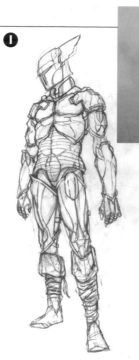

1 Begin with a pencil sketch on normal paper. This is where all the design should be done – in this case, playing around with different details of the armour and headgear.

2 Place the pencil sketch on a lightbox and lay a sheet of bleedproof marker paper on top. Using a light marker, colour the basic form, leaving some white spaces for highlights. These are important because they lend depth to the final image.

3 Go over the image a second time with a darker shade of the same colour to add shadows. Do this fairly loosely and quickly.

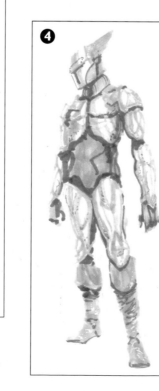

4 Do a third sweep with the darkest marker to add more shadow at the extremities of the figure – underneath armour, for instance. Certain markers have three separate nibs. Use the fine nib to add a few spots and blemishes here and there to age the armour a little.

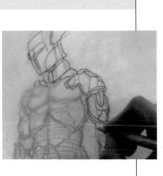

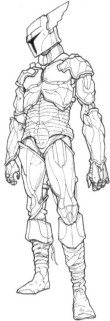

5 Add some final highlights with a white paint marker. You can see from this close-up that the detail work is crude but the overall effect is cohesive and consistent.

6 Use a technical pen with a fine nib to draw over the original lines. Resist the urge to add shadow and unnecessary detail. Use a thicker nib to draw around the outline and the main pieces of armour. This strengthens the image enormously.

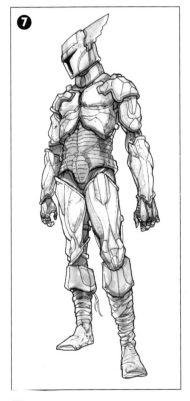

7 In the final artwork you can see how the marker work, which was very loose, becomes cohesive when the pen line is added. The overall impression is a tight, dynamic design.

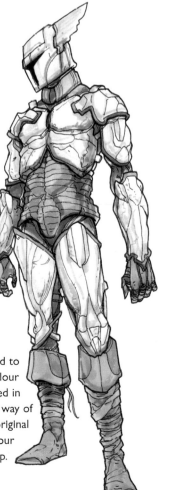

8 The original design can be used to produce a variety of different colour schemes, a choice usually required in film design. This is also a quick way of making modifications to the original design. In this case, the colour scheme was changed in Photoshop.

MARKER TECHNIQUES

NIB SIZES
Some markers are available with three different nib sizes, allowing the artist more control.

HIGHLIGHTS
This detail was created using the three different nibs. Highlights were added with a white paint marker afterwards.

BLENDING
Marker colours can be blended, but only when first applied. There is a special blender marker available for doing this but the effect is very subtle. The trick is to use colours from the same tonal range. Avoid using colours that contrast.

PAINTING AND INKING marker set design

THE TECHNIQUES USED FOR THE RAPID PRODUCTION OF SET DESIGN
VISUALS ARE SIMILAR TO THOSE FOR DRAWING FIGURES. THE ARTIST
ALSO HAS THE CHOICE OF USING ADDITIONAL INK AND WHITE PAINT
TECHNIQUES TO ENHANCE THE VISUAL.

Markers are the fastest way for an artist to produce a drawing that gives an
indication of depth and light. You can see from the examples shown here that a
pencil drawing is just a drawing, but the marker visual
gives us enough to imagine what the subject may look
like on screen. This is essential to the filmmaking or
game-design process, in which the production team
may need to look at dozens of visuals like these before
committing to a design that will eventually be built.

1 Draw a pencil sketch. This
is the ideas stage where the
image should be organized
and all the design decisions
made. Be careful not to leave
anything out. In this case, you
can see that the perspective
lines have been left in to help
guide the rest of the process.

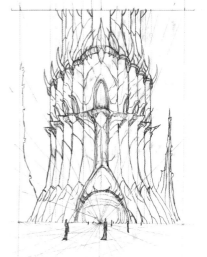

2 Place the pencil sketch
on a lightbox, lay a sheet of
bleedproof marker paper on
top and apply the first marker
colour. Notice that the entire
picture surface has been
covered except for the icy
foreground. White areas are
left for highlights but many
of these will be covered later.
Choose which angle the light
source will come from. In this
case, the left-hand side of the
building has been favoured as
the lighter side.

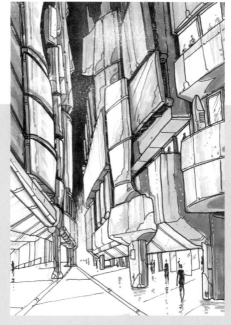

Three shades of marker were used to
build up tone and shadow in this city scene.
Metallic highlights on the buildings were
created by leaving blank patches, with a few
dots of white added with a paint marker.
'City Sketch', Finlay Cowan

OVER TO YOU

■ *If you are unfamiliar with the rapid style of visualization demonstrated here, take a look at
the 'Making of' books that are available for the Star Wars and Lord of the Rings movies.
You will find many excellent examples of this type of design work.*
■ *Marker work is rewarding for anyone orientated more towards design than illustration. Use it
to create several backgrounds for some of your fantasy characters before deciding on the one
you want to develop into a finished visual.*

This rough design for a
sci-fi set is composed of
organic forms. Black ink
was used for the outlines
and a few details, while
most of the surface texture
was created with markers.
'Pod House', Finlay Cowan

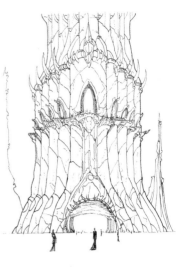

3 Add a darker shade of colour. Fill in the darker tones with much more detail, working into each corner more accurately than you did with the first shade. Add more highlights with a white paint marker, including a thick white outline to the building.

4 Apply more white effects to the towers in the distance and the reflections of the building in the foreground. Use markers to draw the foreground figures.

5 Use misting or frosting effects to soften areas of the image. You can do this by flicking or blowing white paint from a toothbrush or by applying white paint with a small piece of sponge.

6 In this case, the pen drawing was produced on a separate overlay, although this is not necessary. By tracing over the original pencil line and the colour overlay at the same time, you can make very slight modifications and additions to the original line work that will benefit the colour and shading. Be careful not to stray too far from the original, though.

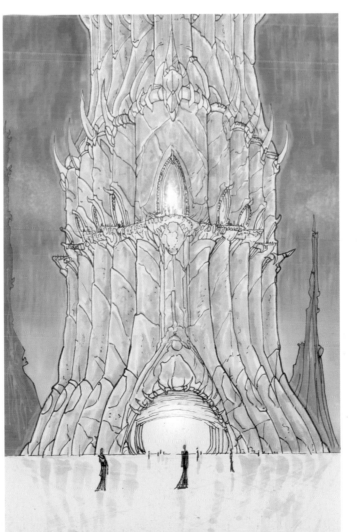

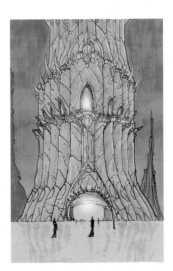

7 The final image was composited in Photoshop and a number of adjustments and digital effects carried out. These included darkening the background, adding highlights and colourizing the line work.

8 Here, the turquoise colour scheme has been changed to a brown one in Photoshop. You could produce numerous different colour variations using the same marker drawing.

PAINTING AND INKING watercolours

WATERCOLOURS ARE IDEAL FOR DRAWING QUICK SKETCHES AND CREATING BLEED EFFECTS. ALTHOUGH WATERCOLOURS CAN BE UNPREDICTABLE AND DIFFICULT TO CONTROL, THE PIGMENTS HAVE A RADIANCE AND TRANSLUCENCY THAT MAKES THIS MEDIUM WELL WORTH EXPLORING.

BLEEDING

1 Bleeding is produced by liberally dousing the surface with clear water and then spotting colours into the water with a brush. The colours will run and the effects are hard to control but the result can be impressive.

2 Drawing with the brush while using bleeding techniques can produce interesting patterns and visual effects, such as smoke and fire or abstract backgrounds, as shown here.

SOFT BLENDS

Paint a single colour such as yellow using regular brush strokes. Allow it to dry partially, then paint over it with a second colour. Watercolours are translucent and allow the first colour to appear through the second.

ROUGH BLENDS

Add more colours while the initial colours are still slightly wet. This way, colours can be merged with a certain amount of control.

STIPPLING

Paint a single colour such as purple. Allow it to dry partially, then stab the surface using a dry brush. This method destroys brushes very quickly, so use an inexpensive one.

DABBING

Add an initial colour such as yellow. Allow it to dry fully, then add a second colour. While the second colour is still wet, dab it with a scrunched tissue or cloth. Try other materials, such as a sponge or dry leaves, for different effects.

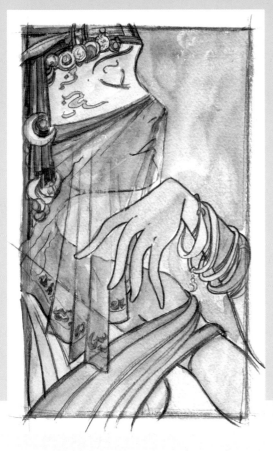

'Christmas Card', Finlay Cowan

Watercolours can be a quick method of producing multiple artwork. The original drawing was placed on a lightbox, and a series of watercolour sketches were produced in quick succession for this series of personalized Christmas Cards. 'Christmas Card', Finlay Cowan

OVER TO YOU

■ *Do some swatches to practise bleeding and blending watercolours.*
■ *Now apply these techniques to one of your sketches, making a series of colour tests of the same image. Note how different colours and application techniques can alter the look of the finished image.*

Watercolours were used to produce several different interpretations of this graphic image, a logo for the Anglo-Asian musician Talvin Singh. 'Talvin Singh Logo', Finlay Cowan

COLOUR TESTS

Watercolours are ideal for producing a series of quick colour tests, which can have an enormous influence on the outcome of the final piece. These tests were carried out as small watercolours. The pencil line was traced for each one, which also provided the opportunity to refine graphic elements.

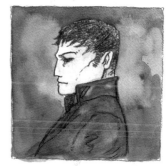

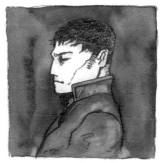

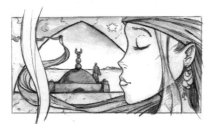

TECHNICAL EXPERIMENTATION

This colour sketch allowed the opportunity to figure out how the translucency of the veil might be approached. The pale purple colour scheme from the first colour test was then replaced by a bold primary red. In addition, the expression of the figure was more clearly defined, giving the image its impact.

TONAL RANGE

A background using two tones added depth to the first colour test, while a blended background produced a monochromatic effect that made the second test more graphic.

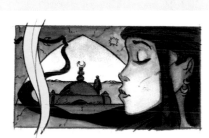

COLOUR PALETTE

It's always good to take more than one 'run' at an image. The final study was a great improvement. The colour palette was narrowed and a good idea of the tonal blends and gradients was realized.

PAINTING AND INKING oils and acrylics

IT WOULD BE POSSIBLE TO FILL A LARGE VOLUME ON THE MERE BASICS OF PAINTING IN OILS AND ACRYLICS. CONSEQUENTLY, I HAVE AIMED TO COVER JUST A FEW OF THE TECHNIQUES THAT ARE MOST COMMONLY USED IN FANTASY ART. I'VE ALSO MADE LITTLE DISTINCTION BETWEEN THE USE OF OILS AND ACRYLICS, AND PRESENTED THE TECHNIQUES IN SUCH A WAY THAT THEY APPLY TO BOTH.

Before applying paint to your drawings, you will need to mix the required range of colours. Different colours affect each other to different degrees, and learning to mix pigments can be a matter of trial and error. To begin with, mix small amounts and then build up the quantity gradually so that you do not waste valuable pigment. It is usually best to restrict a mixture to no more than three colours to avoid muddying, a problem you will inevitably encounter unless you intend to specialize in depictions of battlefields.

COLOUR CHARTS

The three primary colours are red, yellow and blue, but you will find there are both warm primaries and cool primaries. Pairs of adjacent primary colours can be mixed to form the secondary colours orange, green and violet. Each primary colour and the secondary colour opposite it are known as complementary colours and produce a vibrant result when used together. The colours at the centre of each chart are the result of mixing all three primaries.

French ultramarine
Winsor blue
secondary colours
WARM PRIMARIES
cadmium red
cadmium yellow
COOL PRIMARIES
alizarin crimson
lemon yellow

SUPPORTS

The choice of support includes canvas, plywood and strong cardboard. If you find a white canvas inhibiting, you can apply a 'ground', which is a layer of colour on which to build the rest of the painting.

1 For a ground with a consistent finish, choose transparent colours such as yellow ochre, raw sienna, burnt sienna or a neutral grey. Then use the same colour to add dark and light areas to the painting.

2 For a textured ground, choose a darker colour than the one you want and thin the oil paint with turpentine and the acrylics with water. Apply the colour and then lift some off with a cloth while it is still wet.

SHARP EDGES

Sharp edges are best achieved by working wet-on-dry to get a clear definition between edges.

GRADATIONS

1 For a smooth, barely visible gradation from one colour to another, prepare a colour mixture for each. Apply the colours close to each other, using separate brushes so that the colours do not mix.

2 While the paint is still wet, mix the colours into each other with a bristle brush, then switch to a fan brush to work across the area where the paints meet.

BROKEN EDGES

Broken edges, such as you might find on clouds, are created by working wet-into-wet and pulling the two colours into each other along the line. This can also be done using scumbling.

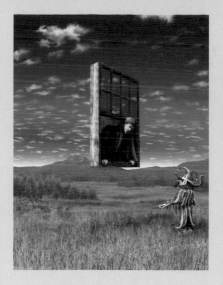

Fades, textures, clouds, foliage and cloth are all used to great effect in this surrealistic image created for the cover of a fantasy book. 'Fletcher', David W Luebbert

OVER TO YOU

■ *You may want to begin by experimenting with some of the techniques described here before actually considering painting an image.*
■ *Alternatively, why not come up with a simple design that showcases one or two of the techniques and learn them one at a time?*

Subtle blends of colour and texture are used to integrate clouds, landscape and architecture. 'The Giants', Christophe Vacher

LIGHTENING A COLOUR

If the paint is still wet, you can lift it with a cloth to lighten it. If it's dry, scrape it away with a palette knife, which can produce some interesting textures, as shown here. Alternatively, you can add a lighter shade over the top.

SCUMBLING

Scumbling involves breaking up the original colour by laying another colour on top to create depth or texture. Working over a dry coat, add the new colour with an almost dry brush. This can also be done with a sponge or rag to create different textures. If your colours become dull as you add more and more paint to the canvas, try scumbling another colour over the top, such as a complementary colour (yellow over green, for example).

BRUSH MARKS

Visible brush marks are created using a stiff bristle brush. Linseed oil mixed into the paint will also help the paint to retain its shape. This technique is less common among fantasy painters, who generally prefer a smoother, hyper-realist look. A smooth surface with no brush marks is produced by mixing artists' medium into the paint and using soft, sable brushes.

GLAZING

Adding paint in glazes is a useful way of building up depth and colour in a painting. Using a medium or glaze makes the paint slightly transparent so that you can see the colours beneath. This is particularly useful for painting metal, water and glass. Apply the paint with a soft brush.

OVERWORKED AREAS

Some areas can become clogged, and you can lift some but not all of the paint by using a smooth, absorbent paper, such as newsprint. Press the paper against the paint surface; when you remove it, it will take some of the paint away. You can repeat this process until satisfied with the amount removed.

PAINTING AND INKING painting a figure

FOR THE BEGINNER, IT MAY BE HELPFUL TO USE AN ACCURATE DRAWING TO GUIDE YOU WHEN PAINTING A FIGURE IN OILS OR ACRYLICS. IN THIS EXAMPLE, I DREW THE WIZARD IN MIRROR IMAGE ON A SEPARATE PIECE OF PAPER, THEN FLIPPED IT OVER AND TRACED IT DOWN ONTO THE CANVAS. The painting is treated loosely at first and then the tones and textures of the figure are gradually tightened up in successive sweeps. This figure is painted alone, so I had to imagine what effect the background would have on it. The light source is coming from the wizard's staff, which has a powerful effect on the whole image. Skin and clothing tones will often reflect the overall colour balance of the picture. Using too many contrasting colours, such as a purple robe against pink skin against yellow walls, would make the overall effect jarring. Limit the colour palette and work with hues of the same colours to begin with. Add complementary colours to details afterwards.

1 Renaissance artists used green, blue and purple underpainting for flesh areas. Painting pale pink glazes or thin transparent glazes over these tones gives them a rich, glowing effect.

2 Needless to say, the wizard's craggy features mean his face will have clearly defined shadows.

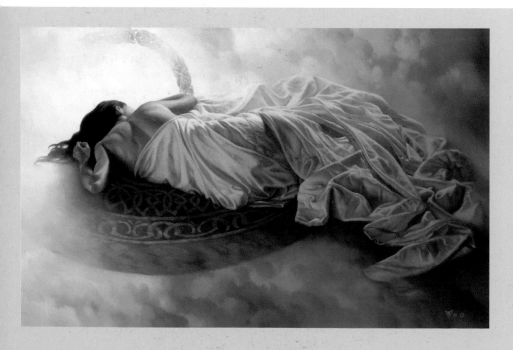

OVER to YOU

■ *Practise painting small areas of skin and cloth before embarking on a whole figure. Experiment with complementary colours and glazes to achieve realistic effects.*
■ *When you are ready to paint a figure, decide on a colour theme for the image. It is best to limit your palette to begin with.*

Careful use of shadows and highlights can lead to an almost photographic representation of cloth.
'Endless Dream', Christophe Vacher

3 Convincing folds in cloth are produced using about five shades of blue. Mix all of the colours you will need in advance.

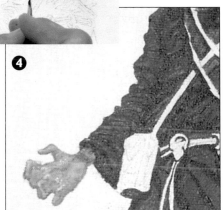

4 Begin with the dark areas and keep the paint thin to begin with, then apply the highlights last with thicker paint. A light tone against a dark one suggests a sharp change in the direction of the fabric. A gradual transition in tone would suggest a curving surface.

5 It is a matter of personal taste, but many fantasy artists prefer to blend their colours to as smooth a finish as possible. Ultimately, a well-practised fantasy painter will aim to achieve an almost photographic finish, which will bring a sense of realism to an unreal subject.

6 With an image that has a powerful and specific light source, glazes can be useful for creating a homogeneous shadow across the whole image. Glazes thin out the paint and allow the colour beneath to show through. Remember that a glaze will affect the colour beneath, so you can experiment with complementary colours. For instance, a transparent ultramarine glaze painted over yellow will produce a green. Glazes are also useful for building up luminescent effects on skies and seas.

7 Build up the beard with successive layers of blues and greys applied with a very fine brush. White strands were added last to break up larger areas of shadow and add a frizzy outline.

8 The painting was quite small and painted on economy board, so the grain of the surface affected the smoothness of the image. I rectified this by retouching the figure in Photoshop. Visible grain is more of a problem when painting with acrylics than with oils, because the longer drying time of oils allows you to work the colours into each other more to produce smooth, delicate blends.

PAINTING AND INKING painting a landscape

START WITH A DETAILED UNDERDRAWING IF YOU ARE A BEGINNER,
LIKE YOU DID WHEN PAINTING THE FIGURE ON PAGES 106–107. AS
YOU GET MORE EXPERIENCED, YOU MAY PREFER TO USE JUST A FEW
GUIDELINES. IN THIS EXAMPLE, THE LINE WORK WAS DRAWN
DIRECTLY ONTO THE CANVAS.

2 Paint the sky using three colours of a similar hue. Apply them separately, each with a clean brush, but do not blend them.

5 Dabbing with a sponge or rag can add layers of mistiness or subtle depth effects. You will often find that layers of different types of clouds will enhance the depth of the sky. Wait until each layer has dried before starting the next one.

1 Underpainting is used by some artists to give a tonal base on which to build the painting. Choose just a few neutral colours thinned with turpentine if you are using oils or water if you are using acrylics. Underpainting can be particularly useful in landscapes because it is a quick way of sketching out the picture.

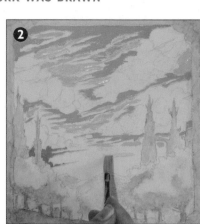

6 Now work on the rocks and stones. Begin with a palette of five tones and work from dark to light. There is a lot of contrast at this stage.

3 While the paint is still wet, gently dab a clean brush over the dividing lines to blend the colours together. Repeat this process with a finer brush to increase the subtlety of the blending. You can also use a finger.

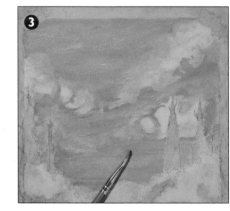

4 Paint the clouds. The lightest area of a cloud is not at the edges unless it is backlit. The upper edge of the cloud will reflect the sky, while the lower edge will reflect the ground. The lightest area is the centre.

7 Add more layers of colour, thinned with water or turpentine, to build up the dark areas. The original dark lines are soon softened and blended. You can add more depth by scumbling with a dry brush, cloth or sponge or scraping away the top layer of paint with a knife.

The gentle foliage in this sylvan idyll is defined more by light than detail. The subtle layering of colour creates depth and form out of light and atmosphere.
'The Gate', Christophe Vacher

8 Green foliage can be enhanced by underpainting with warm browns or reds. Rather than trying to paint individual plants or leaves, work in areas of dark and light. Develop a consistent type of brush stroke to build up the form, and use multi-directional strokes. Begin by blocking in the dark areas.

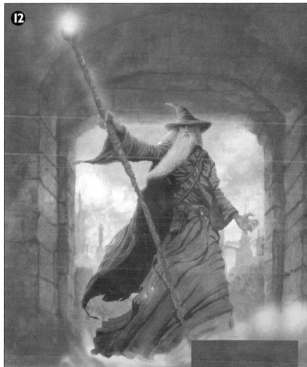

9 Add a medium green to provide the rest of the foliage, then apply highlights and shadows with glazes or thinned paint. You can also use a dry brush to scumble areas of foliage and create good feathering effects.

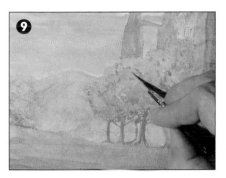

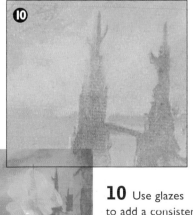

10 Use glazes to add a consistent shadow across the image and to build up luminescent effects in the sky and on water.

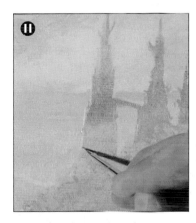

11 The hard, clean edges popular among fantasy painters would be very difficult to achieve painting wet-into-wet, so let your painting dry. You can then tidy up the edges of the main elements of the painting, working from dark to light as before. Finish by adding highlights, using the thickest paint.

12 The final image was colour adjusted in Photoshop. The wizard figure was then introduced and colourized to match the background. The wizard was flopped left to right and a lot of lighting work and smoke effects were added digitally as well.

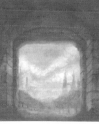

DIGITAL ART hardware and software

UNTIL FAIRLY RECENTLY THE WORLD OF DIGITAL ART WAS SHROUDED IN MYSTERY. FORTUNATELY, ALL THAT HAS CHANGED AND THE BEGINNER CAN QUICKLY GET THE HANG OF A NEW GENERATION OF HARDWARE AND SOFTWARE THAT IS EASY TO USE AND EASY TO LEARN.

HARDWARE

COMPUTER

Nowadays, even the most basic computer is powerful enough to run most software applications and has plenty of memory to store your work, at least to begin with. However, video and animation can take up an enormous amount of space, so bear this in mind if you are thinking of getting into these areas. Macintoshes are very popular with designers, artists and musicians, while PCs are renowned for their animation capabilities. Laptop computers are just as capable as desktop computers but have the advantage of being portable. You generally have to pay a bit more for this luxury, however, and they are easier to steal. Many designers prefer to have a larger monitor, which can be attached to a laptop if required.

SCANNER

A scanner is another essential item. Many non-artists can get by without one, but you'll soon be frustrated at not having any way to put images into your machine. Less expensive models tend to do the job just fine, so you don't have to worry about spending a fortune.

Digital art need not always be blatantly obvious. Subtle use of effects can often be more striking. Photoshop was used to blend two photographs together and apply various filters to create a hand-rendered look. Lens flare was then added using KPT6 software. *'Castles', Bob Hobbs*

Luebbert often uses digital compositions as the basis for his oil paintings, while the digital images themselves are a tour de force of the techniques available. Bryce, Poser, PhotoPaint, and ZBrush were all used in the creation of this image. *'The Lion Queen', David W Luebbert*

GRAPHICS TABLET

Don't even think about trying to produce digital art with a traditional mouse. A graphics tablet with a pen, which is more natural to draw with than a mouse, is essential. This wonderful invention is very responsive, the pressure-sensitive pad allowing you to create a variety of line widths in a single stroke. It will also reduce the risk of repetitive strain injury.

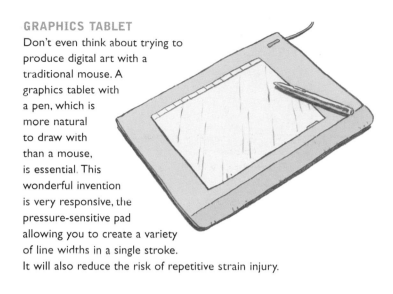

INKJET PRINTER

It may be convenient to send your work out on a CD but there is nothing like seeing it on paper for the best effect. You don't need to invest in an expensive laser printer unless you are producing dozens or hundreds of copies. For most everyday portfolio needs, you can get by with an inkjet printer. Look for a mid-range printer with a service warranty.

CD BURNER

If you buy a new computer, you will have plenty of space on the hard drive to store all your new work, but you have to think about what would happen if your computer broke down or was stolen. CD burners are useful for keeping backups of your work, which you should store in a separate location from your computer. CDs are also the cheapest way to disseminate your work – colour printing can be expensive.

SOFTWARE

PHOTOSHOP

Photoshop is a painting and image-editing package used widely throughout the graphics, film, and illustration businesses, and any artist hoping to work in these fields is expected to have some knowledge of the software. It can be very hard to get started with Photoshop but, once you know what you want to achieve, you can learn in a couple of weeks. There are hundreds of plug-ins available for Photoshop. These are tools and filters that add extra features to the software, such as different brush types or special effects. Photoshop has the additional feature of Image Ready, which is a highly effective package for producing simple animations and preparing artwork for use on the Internet.

PAINTER

Painter is not as well known as Photoshop but is appealing to any artist who has developed traditional skills. Its main strength lies in its wide choice of paint types, mediums and canvasses. The artist has an amazing amount of control over watercolours, paints and inks, along with a tremendous choice of brushes, palette knives and other tools. Many successful painters have made the transition to digital through using Painter and have found it to meet their requirements. Painter is generally used in conjunction with Photoshop.

ILLUSTRATOR AND FREEHAND

Illustrator and Freehand are the most popular drawing packages among graphic designers and comic artists. They are used for producing vector-based images – that is, line illustrations – and are particularly good for creating striking graphics and lettering.

FLASH

Flash is a package created for making websites and is also vector based. The crisp style of artwork that it produces has become very popular, and many illustrators and animators now use it for print and broadcast work.

ANIMATION PACKAGES

Animation packages such as Maya and Lightwave are used for producing feature animation and are consequently enormous, complex and expensive. However, their popularity has resulted in many new entries into the market, which have forced the top industry players to become more competitive and offer 'educational' versions of their software at reduced prices to help artists get started. There are also many packages such as Poser and Vue d'Esprit, which were considered amateurish at first but have developed rapidly into major contenders. Test versions of much of this software is often given away with computer magazines and Is a good way for the artist to explore the software before making a decision about which to invest in.

DIGITAL ART photoshop

PHOTOSHOP IS PARTICULARLY GOOD FOR CREATING QUICK, SIMPLE COLOURING EFFECTS, AS FEATURED IN COMICS. IT IS ALSO USEFUL FOR ADJUSTING THE COLOURS OF COMPLETED ART AND FOR COMPOSITING A SERIES OF DRAWINGS INTO A SINGLE IMAGE.

Compositing is done through the use of the 'layers' feature, which allows you to place each separate drawing on a series of transparent layers. Consequently, each of the layers can be coloured and given digital effects separately from the others, allowing a great deal of control. You should save the final image as a 'psd' (Photoshop document), which retains the layers. You will need to make an additional copy as a 'tiff' file for use in printing, which flattens the layers into one.

WIZARD

1 If your scanned drawing has a strong, unbroken outline, you can select everything around it using the 'magic wand' tool. Now go to the 'Select' pull-down menu and choose 'inverse' to select everything inside the outline – in other words, the wizard. You can also select areas manually using the 'lasso' tool, which can be found on the tools panel just to the left of the magic wand.

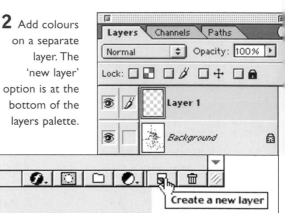

2 Add colours on a separate layer. The 'new layer' option is at the bottom of the layers palette.

3 Fill the image with a single colour using the 'paint bucket' tool. Make the layer transparent by choosing 'multiply' at the top of the layers palette. This will allow you to see the line drawing through the colour layer.

4 Continue to make adjustments to the flat colour by using the selection tools and magic wand on the original line drawing layer, then adjusting the colours using the 'hue and saturation' panel on the colour layer.

GENIE

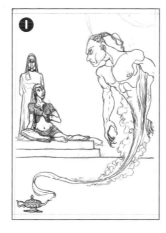

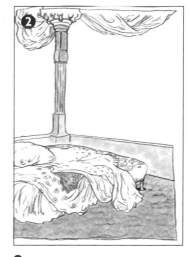

1 Draw a sketch composed of several different elements to figure out how the image will fit together. Draw or trace each element of the illustration onto a separate piece of paper and scan each one. In this example, each of the three characters is placed on a separate layer in Photoshop. A bed and walls will form another layer, and clouds and boat another one.

2 Colour each layer separately, using the same techniques as for the wizard. Here, the bed and walls were opened in Painter software, coloured with a watercolour effect, saved as a tiff file and then reimported into the Photoshop document.

3 Save the final image as a psd document so that you retain all the layers in case you want to change anything in the future.

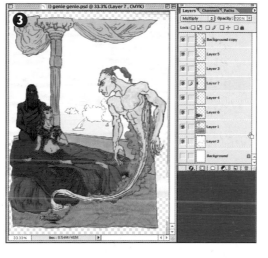

5 Make tonal adjustments using the 'dodge' and 'burn' tools. You can choose from a variety of brush types and sizes for this kind of operation.

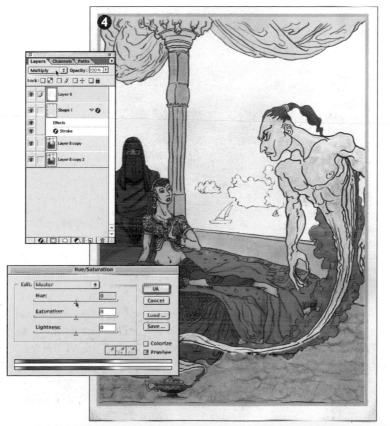

4 Here, it has been saved as a tiff file, which flattens the image into a single layer. The flattened image was then opened as a layer in a new Photoshop document and placed over a layer of a scan of an old book. The colours of the overall image were changed using the 'hue and saturation' panel to create a sepia look. The layer with the genie image was made translucent, using the 'multiply' option at the top of the layers panel, so that the texture of the scanned book showed through.

6 The dodge tool will create highlights in the colour, while the burn tool will create shadows. This is useful for creating depth and has become very popular with comic book colourists.

DIGITAL ART painter

PAINTER IS A SOFTWARE PACKAGE USED TO APPLY DIGITAL PAINT AND INK EFFECTS TO DRAWINGS. IT IS PARTICULARLY POPULAR, THEREFORE, WITH TRADITIONAL ARTISTS WHO WISH TO MAKE THE TRANSITION TO DIGITAL ART.

I generally find that the first two days on any new medium are the worst, then it starts to get easier, so don't lose heart if you are new to this package. The truth is you'll always be struggling with some new skill or developing skills you already have, and you should see this as a positive process. I decided to paint each element of this illustration as a separate Painter document, then put them together in Photoshop.

2 Copy and paste the first source image – in this case, the figure – into a new layer in Painter so that it is possible to paint behind it. Select a new layer from the 'objects' panel.

1 Trace each element of your compositional drawing and scan them separately. Here, the figure, trees, sky and ground are all different scans.

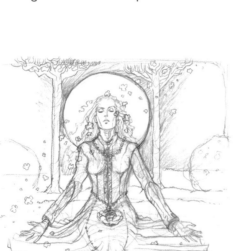

3 Choose the paper surface from the 'art materials' panel and the type of brush from the 'brushes' panel. I chose an impasto brush. Adjust the brush size using the 'control' option on the brushes panel.

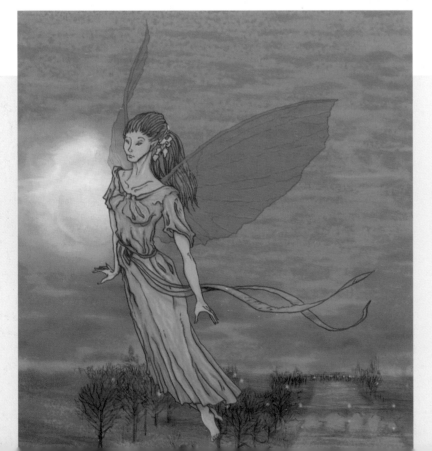

OVER TO YOU

■ *Painter offers incredible flexibility in the choice of brushes and effects, so spend a few days creating various paint swatches.*

■ *Once you've got to know a few brush types and effects that you really like, start to put an image together using them.*

Painter can be used to create fairly convincing watercolour effects, such as the background of this image of a fairy. *'Fairy', Finlay Cowan*

4 Choose a colour from the colour wheel and use the brush to apply paint underneath the original drawing. The software responds to pressure and stroke direction. Choose a darker tone to paint the shadow areas.

5 Add more colours to the drawing, with each colour on a separate layer. This will allow you to correct errors without having to start the whole thing again. If you go over the edge of a line, you can erase it later.

6 Save the final paint layers as a tiff file, with the drawing layer switched off (this can be put back in later in Photoshop).

7 Carry out the same process on each of the other elements. The sky was painted using a dry watercolour brush, which was used to build up textures and colours. The texture on the moon was created using bleaches, salt erasers and water spatters.

8 The rest of the work was carried out in Photoshop. Each layer of the line drawing had to be cut out so that the layers behind it would be visible. This was done using a combination of the magic wand and lasso tools (see page 112).

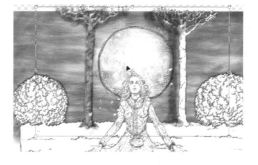

9 Insert the Painter files into the Photoshop document, each on a separate layer. You will need to resize them carefully using the 'transform' function, which you'll find in the 'Edit' pull-down menu.

10 The overall effect at this stage lacked harmony and cohesiveness, so I adjusted the hue and saturation of each colour layer to try to harmonize them. I also carried out a lot of work using the 'rubber/clone stamp' tool. Use this to clone areas of colour from one place to another and for cleaning up edges and smoothing out colour.

11 I was not happy with the overall homogeneity of the image, so I copied the ground layer, stretched it over the whole frame using the transform function, and adjusted the colour. This smoothed out the whole image and added an extra layer of texture that helped bring the piece together.

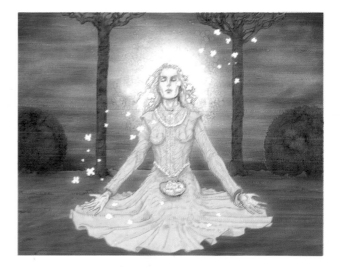

12 Make final adjustments to the colour. Here, these included colourizing the line drawings using the hue and saturation control and adding highlights and shadows using the dodge and burn tools (see pages 112–113).

DIGITAL ART 3D hero

MANY ARTISTS ARE MAKING THE TRANSITION TO DIGITAL BY USING 3D MODEL-BUILDING PROGRAMS THAT CAN PRODUCE BOTH STILL IMAGES AND ANIMATION. SOME OF THE CHEAPER PACKAGES ON THE MARKET, SUCH AS POSER, ARE EASY TO LEARN AND VERY POWERFUL.

Poser is used mainly for building three-dimensional figures that can then be dressed and moved into any position required.

Vue d'Esprit is a software package used for producing backgrounds and sets and can be used in conjunction with Poser, as demonstrated here. Needless to say, it's only possible to show roughly how an image is put together in this amount of space. The examples shown here and on pages 118–119 were produced by digital artist Nick Stone.

2 A skin can then be added from a choice of coverings.

3 Many of the tools in Poser are fairly easy to understand. This palette shows the controls for positioning the figure. Each element of the body can be moved individually.

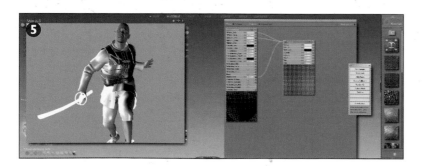

4 You can add clothes specially modelled to fit the character. Those shown here were available to download free from the Internet. You can also add props, such as a sword.

1 Start with a basic wire-frame Poser model. This contains bones that act much like a real human skeleton. In addition to using the basic figures supplied as part of the software package, you can download ready-to-use models from the Internet.

5 You can now concentrate on the surface textures of the model, selecting the skin colour and textures for the clothing and props.

6 This palette shows a few of the different surfaces and textiles than can be applied to the various elements of the figure. There is a large library of coverings available.

7 This palette shows the many controls available for adjusting the surface once it has been selected.

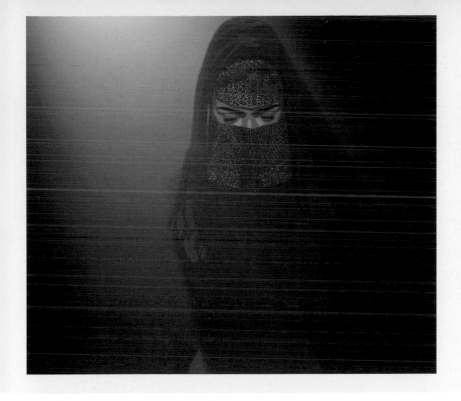

A basic human face supplied as part of the Poser package can be adjusted and developed into any character you have in mind. 'Scheherazade', Nick Stone & Finlay Cowan

8 Here, a background image created in Vue d'Esprit has been imported behind the figure. You can adjust the lighting on the figure so that it matches the background light.

9 You can continue to manipulate the position of the figure to suit the background image. This palette shows the controls for the hands. You can see on the right the variety of different poses, with the controls for each pose on the left.

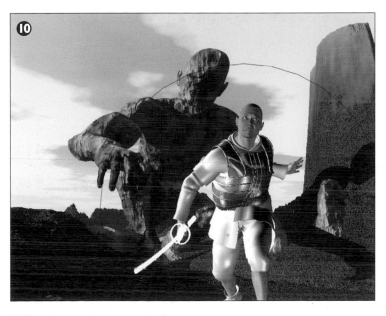

10 This final picture is a kind of 'working copy'; it needs to go through a 'rendering' process to finish it off. This can take a long time, depending on the size and complexity of the image. Remember that you can always go back into this image and repose the figure in any way you wish, which is why it requires a lot of memory and rendering takes a long time. At this point, stop working, go out and get some sunlight, and let your computer get on with it

This image was produced for an animation that took stories from *The 1001 Nights* and transposed them to a modern-day city setting. 'Rashid', Nick Stone & Finlay Cowan

DIGITAL ART 3D ogre

ALTHOUGH THERE ARE MANY BASIC POSER MODELS TO CHOOSE FROM, IT WON'T BE LONG BEFORE YOU WANT TO CREATE YOUR OWN, MORE INDIVIDUALISTIC FANTASY CHARACTERS. THIS CAN BE ACHIEVED BY 'MORPHING' THE VARIOUS ELEMENTS OF THE BASIC MODEL INTO THE SHAPES YOU REQUIRE.

Poser software is renowned for being intuitive, which means that it is, to some extent, self-explanatory. However, even the most psychic Jedi sometimes needs a manual, and all software comes with guides, useful tutorials and on-line help.

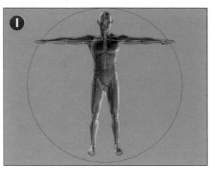

1 Start with a basic Poser figure and apply a skin covering.

2 Morph channels, known as 'morph putty', allow you to change the shape of the head and other body parts.

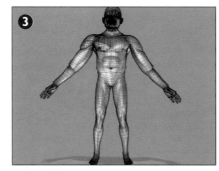

3 You can change the proportions of the body to produce an ogre's physique. Here, the arms have been lengthened and the musculature of the upper body increased.

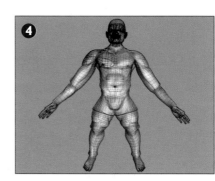

4 The legs are also more heavily muscled, but this time they are shortened to produce the disproportionate anatomy of an ogre.

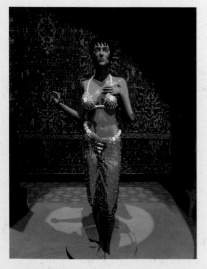

Particle effects were used to create the dancer's shimmering skin and enhance her mystique. *'Scheherazade Dancing'*, Nick Stone

OVER TO YOU

■ *Practise different morphing techniques to create two or three fantasy figures. Start by copying the ogre shown here, then develop another ogre to your own design.*
■ *Place your ogres into different poses. You could perhaps show them ready to do battle with each other.*

This test shot of a snake for an animation sequence was downloaded from the Internet and animated over a Photoshop background. *'Snake'*, Nick Stone

5 POSE | MATERIAL | FACE | HAIR | CLOTH | SETUP | CONTENT

5 There are many options available for even the simplest character design, so it is a good idea to store the attributes you choose for your character in a series of subfolders. This will make it easier to work without the desktop becoming cluttered with visual information.

6 Once you're happy with the figure, you can position it by choosing from a library of poses. Just as you can manipulate the physique of the model, you can also modify the pose.

7 The artist has a reasonable amount of control over every detail of the figure. This dialogue box shows the controls for the left hand.

8 Once you are satisfied with the look of the character, it can be exported as an 'object' file to place in the landscape. In this case, Vue d'Esprit software was used to produce the landscape, but Poser files are compatible with most animation and design software.

9 The ogre object file can then be imported, positioned and scaled to fit the background.

10 The view of the landscape and figure is controlled using a camera-positioning tool.

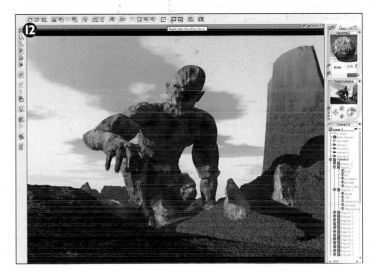

11 Here, a suitable material is chosen to cover the figure of the ogre. The software will wrap this material around the object you select and render a realistic image... if you could call this realistic.

12 The final image is now ready for the addition of more characters, effects and, ultimately, animation. I used it as the background image in the Poser hero example on pages 116–117.

DIGITAL ART 3D landscape

MANY ANIMATION AND GAMES DESIGNERS USE SOFTWARE LIKE VUE D'ESPRIT FOR MODELLING AND ANIMATION. THIS EASILY ACCESSIBLE PACKAGE IS A GOOD WAY TO BEGIN, BEFORE GRADUATING TO HEAVYWEIGHT ANIMATION PACKAGES LIKE MAYA.

Vue d'Esprit is generally considered to be the easiest animation package to learn. Many pre-made objects and architectural models are available as free downloads from the Internet. Vue can also import objects made in other programs, such as Maya, and it can read DEM data from satellites, which means you can build accurate maps of the Himalayas or the Grand Canyon for those sweeping fantasy epics you are planning. The images shown here were produced by animator Tim Burgess of Barking Mad Productions to showcase the fundamentals of Vue.

GOTHIC CROSS

All the colours in this image are generated by the effect of a spotlight placed behind two windows, which were each given a different multicoloured glass effect. 'Volumetric lighting' was switched on, which creates atmospheric effects such as dust and rays of light.

Vue allows you to see your landscape from several different angles.

Two rectangles show the positioning of two windows.

The yellow crosses show where lights are positioned.

The gothic cross was downloaded from the Internet.

CHURCH

The church in this image was also downloaded. Lights were placed inside it and there is a spotlight slightly above it to pick out details on the roof – you needn't be limited to a single light source, even in exterior images.

Imported architectural forms have been located so that they intersect a water line to create an illustration of a flooded ruin. *'Flooded Ruin'*, Tim Burgess

TERRAIN AND FOLIAGE

Pop-up control panels give you a choice of terrain and foliage. The terrains are designed to vary according to different environmental conditions, such as altitude. 'Scrubland' will always put grass on certain levels and rock on others. Foliage is generated using fractal algorithms so that you never get the same shape twice. You can also sculpt and edit your terrain and foliage according to your godly desires.

ICE FLOW

1 Vue comes with enough choice and capability for the average fantasy artist to produce a lifetime's worth of work. This ice floe shows how complex patterns can be produced by layering effects rather than building complex models. The broken ice was created by applying 'caustic' texture effects to a plain ice surface, then adding a darker layer beneath them to merge them together.

2 This aerial map shows the ice flow as the square in the bottom right corner, with the mountains ranged towards the top left. The white dotted lines show the viewpoint of the main image.

TOWERS

1 This image was made entirely in Vue without using imports. Vue provides basic objects such as cones, cubes and spheres that can be modified using a technique called 'Boolean'. In this image, a series of towers was created using extruded cylinders. The arches were produced by positioning spheres so that they intersected with horizontally laid cylinders.

2 These wire frames show how the intersecting spheres were made to fit the length of the horizontal cylinders.

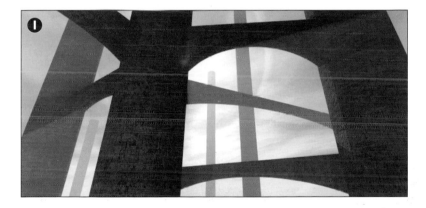

3 The wire frames of the intersecting spheres can be seen in this view. The same method of intersecting one object with another can be used to create windows, doors and interior cavities.

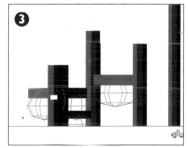

OVER TO YOU

■ *Vue also has powerful animation capabilities, so why stop at a still image when you could be embarking on a one-man epic? You will need time and patience, but it is well worth exploring the program in more depth.*

■ *You will eventually need software for editing, character animation, and adding sound to your creations, so start surfing to see what's out there. You will find that there is inexpensive and accessible software available for these tasks.*

This image of a gothic city uses a restricted colour palette to create a subtle mood. *'Gothic City', Bob Hobbs*

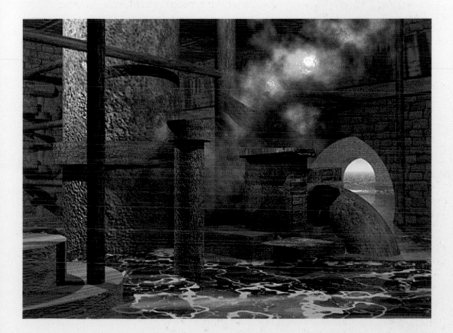

album sleeves

ALBUM SLEEVES HAVE PROVIDED A SHOWCASE FOR FANTASY ART SINCE THE 1960s. THE MEDIUM EXPERIENCED A HEYDAY DURING THE 1970s, WHEN FANS OF GROUPS SUCH AS PINK FLOYD, LED ZEPPELIN AND YES WOULD SPEND HOURS DETERMINING THE DEEPER MEANINGS OF ARTWORK BY DESIGNERS SUCH AS ROGER DEAN AND STORM THORGERSON, WHOSE RECENT WORK IS SHOWN HERE.

The music business is still a major provider of employment for illustrators, designers and photographers, and the industry relies on a steady flow of new and interesting ideas. The artwork pictured here are photographic in their makeup, but they are not snippets of reality in the sense that most photographs are. They are conceived from nothing and carefully put together using a mixture of photography and digital technology. In this sense they can be defined as fantasy because they are a work of the imagination made to look as real as possible.

Storm Thorgerson and his team, which includes Pete Curzon, Jon Crossland, Tony May, Rupert Truman and often myself, rely heavily on the use of drawings in the early stages of the design process. Dozens of ideas are thrown into the hat and every aspect of the final design is figured out in the drawing stage before employing the wizardry of modern technology to bring the ideas to life.

PINK FLOYD, OUTER SLEEVE

This collage with an eye at the centre was for the outer sleeve of the group's double live album *Pulse* and was meant to express, in a graphic sense, the experience of a live Floyd show. Elements of the live show are reflected in the eye, and the style of the artwork is meant to reflect the mixture of old and new material that is presented in a live show. The sleeve is also full of Floyd references, old and new.

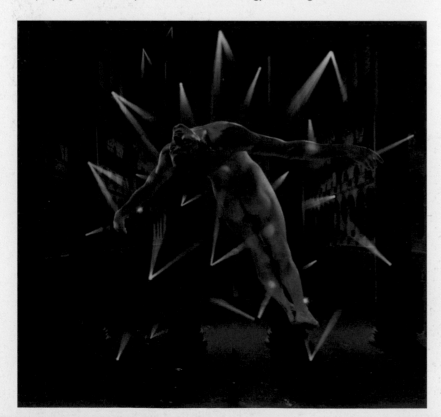

PINK FLOYD, INNER SLEEVE

This image of the suspended man, used on the inner sleeve of *Pulse*, was intended to express the sensation of being carried away by the light and sound at a Floyd concert. The figure is meant to be any member of the audience, and their nakedness defies any categorization. The fantasy was that the lights were tiny little UFOs who were bearing the figure away to some kind of mother ship elsewhere. The image was set in an interior to reflect the notion that most concerts take place indoors.

RICK WRIGHT

Rick Wright, the keyboard player for Pink Floyd, wrote his *Broken China* album based on an abused life. Written in four parts, the story went from the child's earliest memories, through teenage rebellion, an emotional decline and breakdown, and finally recovery. Consequently, the cover image can be taken to represent a number of things. The disk of water could be a mental or emotional whirlpool

into which the abused person is sucked, but it can also represent the breaking through of the individual. The pencil sketch shows another version where the human and broken elements are swapped. The broken figure is self-explanatory and the blurred background could suggest the loss of focus or sense of self.

ANTHRAX

The music of Anthrax had a wonderful, minimal, pared-down quality that was very upfront, so the image of a huge ball of twisted metal was suggested for the album *Stomp 442*, which seemed to capture some of that upfront feeling. Storm described his fantasy for the image: 'It was held together by mental energy, exerted by the figure standing alongside. It was his ball, his personal weapon, his pet metal crusher.'

CATHERINE WHEEL

This sleeve for *Cats and Dogs* grew out of one of my personal obsessions – twins – and is a good example of where using digital work just won't do. Storm knew that this was something that could not be faked, and commissioned Tony May and Rupert Truman to photograph five sets of twins. The differences in the twins are just enough to convince the viewer that they are real, which lends credence to the image as a whole and enhances their fantasy value.

MOODSWINGS

Moodswings' album, *Psychedelicatessen*, was 'an eclectic and amiable mixture of trance, ambient, and reggae with quasi-psychedelic overtones', as Storm put it, and the design was 'based, loosely, on the maxim that the sum of the parts is greater than their whole'. The other suggestion was that we are, in effect, all one, and this subtitled the single release. Needless to say, this image was a horror to produce. Over 400 faces had to be photographed and each one had to be retouched and laboriously assembled by Richard Manning. It was a good opportunity to slip ourselves, our friends, and our families onto an album sleeve, though.

DIGITAL ART format and presentation

THERE ARE SOME FUNDAMENTAL RULES THAT ARE CRUCIAL TO FOLLOW WHEN PRESENTING YOUR WORK TO POTENTIAL CLIENTS OR PREPARING YOUR WORK FOR USE ON THE INTERNET OR IN PRINT. SENDING FILES IN THE WRONG FORMAT CAN SLOW PROCESSES DOWN AND CAUSE YOUR CLIENT FRUSTRATION, WHICH WILL, IN TURN, AFFECT YOUR FUTURE EMPLOYMENT PROSPECTS.

RULES OF PRESENTATION

1 Don't e-mail potential clients large files that will take a long time to download – it will probably annoy them. It is best to send a CV first and an address for your website if you have one. If you are sending a CV by regular mail, it is usually OK to send some samples of your work.

2 Don't send original artwork in the mail. Always send copies. If you want the copies back, make sure you send a stamped, self-addressed envelope.

3 Keep your CV short. Most editors don't have time to read more than a page. Most e-mailed CVs go straight in the wastebasket. It is better to do some research and find the name of the appropriate person to send it to and then send it by regular mail.

4 You can be the best artist in the world but it won't mean a thing if you are unreliable. Most clients would rather use a second-rate artist they know they can rely on rather than have to work around a genius who makes their life even more difficult than it already is. There are many artists who miss deadlines, and little by little the word gets around. It is vitally important to return all calls from clients as soon as possible and keep them up to date on progress, particularly if there have been any changes to your artwork or schedule.

DATA STORAGE

The two main choices for data storage are CDs and external hard drives. I back up all my work on an external hard drive as I go, then once every two weeks I burn all my new material onto CDs. The CDs are kept in a separate location from the computer and external hard drive in case of fire, theft or flood. It's important to take the time to do this, and you need to factor it into your schedule. Losing work is common and it can affect your chances of future employment if you let a client down. It is worth finding a supplier on the Internet who can provide bulk CDs in boxes of 50 to 100 or more. Buying data storage in this way can save you a fortune.

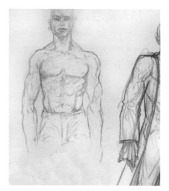

DESKTOP PRINTING

It is generally better to send printouts of your work to potential clients because e-mailed artwork can cause frustration when downloading and CDs require recipients to find time to put it in their machine and open each file separately. A printout gets looked at as soon as it comes out of the envelope.

PORTFOLIOS

It is becoming more common to present samples of work as a pdf (see opposite), but for sheer impact nothing matches seeing a well-presented portfolio. Even if you only use the traditional media of painting and drawing, keeping digital copies of your work is invaluable. An old-fashioned portfolio can go out to only one client at a time. Consequently, it is a good idea to keep a digital document of your portfolio at A4 size to print out from your inkjet when you need it. This method also allows you to mix and match the images in your portfolio according to the needs of the client in question. This method can become expensive, so find a supplier on the Internet who can provide bulk paper and ink cartridges inexpensively. Make an extra effort to find papers that give quality reproduction but don't cost a fortune.

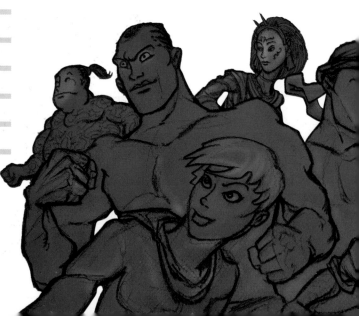

PUBLISHING

Most artwork for print needs to be sized to 300dpi (dots per inch) and saved in CMYK format, which can use a lot of memory and slow your process down. It's possible to work in RGB, which keeps the file size smaller, and then convert to CMYK at the end. This is easy to do in Photoshop. Bear in mind that if the printed image must be 300dpi at the size it will be printed, you can reduce your source images to the final size before working on them so that the files are smaller and therefore quicker to work on.

E-MAILING

Any artwork that only needs to be seen on the computer screen and not printed out can be reduced to 72dpi. If you are working on images for use only on the Internet, you can work at 72dpi. If you are working on an image for print at 300dpi but need to e-mail it to your client for approval, it is important to make a 72dpi copy so that it goes down the phone line as quickly as possible. You can also save it as a 'jpeg' file, which is smaller than a tiff. It only needs to be about 400 to 500 pixels across for use on a computer screen, so you can cut it down that way as well. After you've done this, use the 'save for web' command in Photoshop's 'File' pull-down menu to make another jpeg copy, which is compressed even more. Now you can attach the file to an e-mail and send it to clients without clogging up their system unnecessarily.

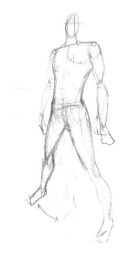

PDFs

Pdf is a format for compressing entire documents of words and pictures for sending down the phone line. You can turn your documents into a pdf using Adobe Acrobat. This is a fairly expensive package but it is becoming an industry standard because recent developments in pdf mean that it is now possible to send a compressed document directly to the printer. If you are working on an illustration, comic or book, this means you will be able to send your final print-ready artwork down the phone line, which will revolutionize the way artists work in conjunction with publishers and printers. It means you will never have to leave the house and can have a successful career as an artist while living halfway up a mountain in Alaska. Many publishers will be able to accept copies of your portfolio this way as well.

WEBSITES

Many editors and publishers look for artists via their websites, and it has become quite easy to build your own website for showing your work. But that's only half of it. It's important to have a website that works efficiently and can be found easily by search engines. For these reasons, it is worth consulting an experienced web designer who can navigate these issues. Bear in mind that potential clients will not be interested in dazzling animations and clever website design. More often than not, they will want to see your work in the quickest, simplest way possible and be able to contact you easily if they are interested. The point is, don't get carried away.

INDEX

PICTURE CREDITS

Quarto would like to thank all of the artists who kindly allowed us to reproduce examples of their work in this book. Each artist is named in the caption accompanying his or her illustration. The illustrations are the copyright of the named artists, with the additional acknowledgements listed below:

t = top; b = bottom; r = right; l = left

6t Theresa Brandon www.theresabrandon.com
6b & 76b Anthony S Waters © Wizards of the Coast, Inc
35t, 39b, 47t & 75b RK Post © Wizards of the Coast, Inc
62b Carol Heyer © Ideals Children's Books
97tl & tr Anthony S Waters © Green Ronin
110bl Bob Hobbs © Talebones Magazine
110br David W. Luebbert, model Karen Eagle
125tl Gary Leach

All other illustrations are the copyright of Finlay Cowan or Quarto. Any illustrations not credited to an artist on the page where they appear are the work of Finlay Cowan, who can be contacted at finlay@the1001nights.com

AUTHOR'S ACKNOWLEDGEMENTS

DEDICATION
To Mum and Dad

SPECIAL THANKS FOR HELP WITH THIS BOOK TO
Chris Patmore, Storm Thorgerson, Steve White, Paul Gravett, Nick Stone, Tim Burgess and Gary Leach

THANKS ALSO TO
Mum and Dad, Neil Cowan, Janette Swift, Joan Swift, Kay and Roger, Justin and Duncan Saunders, David Wilsher, Linda Hill, Jason Atomic, Steven Warner, Sally Keable, Barabara Thomsett, Geoff Whiteley, Mr Scott, Steve Reader, Caroline Owens, Jonni Deluxe, Mike Scanlon, Aimee, Veera Ronkko, Dawn Goddard, Adam Fuest and Adele Nozedar, Paul Claydon, Howard Jones, Matt Barr, Dorothee Inderfurth, Lou Smith, Ross Palmer, Richard Mazda, Christie West, Dave Howard, Daniel T. Howard, Sharmaine Beddoe, Trish and Paul Laventhol, Ron Cook, Chris Iannou, Mark Griffiths, Dulcie Fulton, Chiara Giulianini, Alma and Pelle Fridell, Peter Curzon, Jon Crossland, Talvin Singh, Equal-I, Alan Wherry, Mari An Ceo, Marlene Stewart, Richard Hooper, Carsten Elias Berger, Steve Jones, Ian Paradine, Patrice Buyle, Marcia Shofeld, Richard O'Flynn, Rory Johnston, Richard Bellia, Sean Richardson, Aaron Witkin, Wilf and Edna Colclough, Colette Rouhier, Richard Saunders, Elin Jonsson, Maggie and Scott Monteith, Amy Coffey, Dan Zamani, Mwila Goble, Jon Klein, Kevin Mills, John Watts, Annemarie Moyles, Coleen Witkin, Glen and Ida, Stefan di Maggio, Howard and Asa Tate, Natalie Tate, Franco Farrell, Jonathan Roubini, Carol Bailey, Alan Mahon, Paul Duncan, Sanchita Islam, Robert Hendricks, Ofer Zeloof and family, Adam Bass, James Piesse, Nina Petkus, Sawako Urabe, Albertine Eindhoven, Bill Bachle, Joe Bachle-Morris, Natasha Fox and Adrian, Debbie Williams, Tom Thyrwitt and Lisa Brown, Lindall Fearney, Hassan, Kevin McKidd, Kieron Blair, Lee Campbell, Dave McKean, Alan Moore, Nish Dhaliwal, Thomas Madvig, Owen O'Carroll and family, Peter Archbold, Asa Lindstroem, Pete Williams, Becky Early, David and Hesta Spiro, Christophe Gowans, Gez O'Connell, Ruth and Malek, Jane Mercer, Marianne and Colin Fox, Stine Holte Jensen, Jason Greenwood, Ian Taylor, Jimmy Soderholm, Jefferson Hack, Rankin, Roger Grant, Rose Reuss, Ed Ilya, Jonny Slut, Max Ghalioungui, Anne Mensah, Amanda Galloway, Bahram Safinia, the boys at the garage, Sir Richard Francis Burton and the Muse Goddess